G000130484

CONTE....

	Acknowledgements	5
1	Law and Order	7
2	Education	17
3	Religion	71
4	Health	87
5	Recreation	97
6	Transport	105
7	Business	113

ACKNOWLEDGEMENTS

Grateful thanks to: Michael Scanlon, Sr Aine McNamara and Sr Bernadette McGinn (Daughters of Charity), Sr Maura (Dominicans), Sr Mary John and Sr Mary Gabriel (Carmelites), Fr Sean Farragher (RIP) and Caroline Mullan (Blackrock College), Fr Colm McAdam and Fr Tom Davitt (Vincentians), Revd Gillian Wharton (St Philip & St James), Sr Marie Bernadette and Sr Monica Byrne (Irish Sisters of Charity), Emer McNeice (Blackrock Clinic), Noel Collins (OPW), Ken Mawhinney (Church of All Saints), Dermot Nugent and Jimmy O'Sullivan (Dún Laoghaire Rathdown County Council), Marianne Cosgrave (Mercy Archives), Superintendent John Hand & Garda Jim Daly, Fr Edward Conway and Jeana Cooney (St John the Baptist), Jim Cooke (VEC/ETB), Anne Baxter (Carysfort NS), Ed Penrose and Christy Harford (Labour History Museum), Teresa Whittington (Central Catholic Library), Debra Merriman (Booterstown NS), Carol Bedell (All Saints NS), Martin Taylor (Dublin Crystal), Bill and Mary McSweeney, and all who allowed me to take photos, escorted me around their premises, told me their story, or assisted in numerous ways.

Thanks also to the excellent staff at the National Library of Ireland, National Archives, Irish Architectural Archive, Valuation Office, Dublin City Library and Archives, Blackrock and Dún Laoghaire Libraries, Howth Transport Museum, Diocesan Archives, RCB Library, and the Military Archives at Cathal Brugha Barracks.

Where photos are not acknowledged, they were taken by the author.

1

LAW AND ORDER

INTRODUCTION

In the Down Survey of 1657, there is no such place as Blackrock. Instead there is 'Newtowne of the Strand' in the Barony of Rathdown, the Parish of Kill and Monkstown, the main landowner of which was Walter Chevers, an Irish Papist (Roman Catholic), with 207 acres.

John Rocque's map of 1760 marks 'The Black Rock from whence the town takes its name', a little out from the water's edge, roughly opposite the centre of the present Idrone Terrace. The geology of this area is mostly granite, in sharp contrast to the freak Black Rock (probably black calp limestone).

Rocque's map also shows the boundary line of Dublin City as being roughly the same position where a Martello tower was later built in Williamstown. By the time of the 1837 Ordnance Survey, the city boundary was at the crossroads on the south side of Blackrock, where a stone cross originally stood (outside the present-day Central Cafe), alongside a 5-mile stone marker.

The north part of the townland was in the Fitzwilliam Estate (later called Pembroke Estate). Other parts of the townland were owned by the Proby Estate – the Proby, Carysfort and Allen families were all inter-related.

BLACKROCK TOWNSHIP

Blackrock became an independent township under the Blackrock Township Act 1863, with initial meetings of the Commissioners held in Rock Lodge. A detached five-bay town hall was opened in 1866 in Newtown Avenue, and became the venue for various concerts and public meetings. In 1880, a first-floor extension was built on pillars at the centre rear of the town hall off the imposing staircase, to house a new council chamber with feature roof trusses and large lantern roof light.

In 1898 Blackrock became an Urban District Council (although part of the area was in Rathdown No. 1 Rural District Council) until, in 1930, it was taken in charge by Dún Laoghaire Corporation. Finally, in 1994, Blackrock became part of Dún Laoghaire Rathdown County Council.

When the Carnegie Library and Technical College were built in 1905, alterations were also carried out to the town hall – the first-floor front concert hall was

enlarged, with the stage taking up about half of the first floor in the adjoining new library. No doubt Carnegie would not have liked his library fund being used for entertainment purposes!

In 2013/2014, the former town hall was refurbished, extended and altered, in conjunction with the adjoining Carnegie Library and Technical School (including infilling the space between the town hall and the Methodist church), to create Blackrock Further Education Institute, and a public library. The former 1880 council chamber extension to the town hall has been demolished, and a chamber/ staffroom recreated at first-floor level in the south-east corner of the adjoining former Technical School, including a lantern roof light overhead. The ground floor of the former Technical School has now been allocated as the children's section of the library.

Scoil Lorcan was started in the former town hall in 1952, and moved to new premises in Eaton Square in 1956.

GARDA SÍOCHÁNA

There was a Dublin Metropolitan police station in Newtown Avenue in 1835, beside Rathdown Petty Sessions Court which, in the 1840s, moved to a Georgian house in the lane to the south of present-day Jack O'Rourkes pub (15 Main Street). In 1925, the DMP became part of the Garda Síochána (Guardians of the Peace), which had been set up in 1922. In 1993 the Garda moved to a new building on Temple Road, and the former station is now used by the Inland Fisheries Board.

There was another DMP station called Oak Lodge police station in Booterstown – new houses, 1, 2, 3, 4 & 5 Grotto Avenue are now on the site.

The 1901 Census records the DMP in 15a Main Street, with two sergeants (one RC and one Presbyterian) and fifteen constables (two are C of I, two are Methodists, one is Presbyterian, and ten are RC). In the 1911 Census, there is one sergeant (RC), and sixteen constables (one C of I).

A 1931 floor plan gives a flavour of that era: flower beds in the forecourt, bicycle shed (no squad cars then), coal house (no central heating), two cells, etc. Alterations were carried out in 1938, including rebuilding the rear annex, with two dormitories on the first floor, one for nine men and the other for five men – the sergeant had his own bedroom in the main building.

MARTELLO TOWERS

There were twenty-six Martello towers along the Dublin coast, from Bray to Balbriggan, all erected rapidly by the Ordnance Board (part of the army) in 1804-05, in case Napoleon Bonaparte, Emperor of France, attacked Dublin. Such an attack was never attempted, and the towers were never used in combat. Napoleon was defeated by the allies at Waterloo (then in Holland, but now part of Belgium) in 1815, under the command of the Duke of Wellington (commemorated by the Wellington Monument in the Phoenix Park).

These round towers can be seen all over the world, and the name and design has Spanish origins. Most of the Dublin towers are built with ashlar granite, about 7.5 metres (25 feet) high, and 12 metres (40 feet) diameter. There are two storeys, one at ground level, with standard headroom, and the main open-plan one at first-floor

level, with a single-arched stone roof overhead. External access is via a timber staircase to a first-floor door, with a machicolation overhead to allow attack on intruders, and internal access is via a narrow spiral staircase built into the 2.4 metre (8 feet) thick walls. There are only a few small ventilation openings for the entire tower. The cannon gun, firing 18-pound cannon balls with a range of about 1.5 kilometres, sits on a timber carriage on the roof, screened by high parapet walls, and can be pushed around on a circular steel track to point in any direction. These towers were lived in by about twelve artillery soldiers.

After 1815, the towers were used by the Coast Guard to ward off smugglers, but gradually fell into disuse, or were adapted for civilian use. Williamstown Tower (No. 15) in Blackrock Park is listed in *Thom's Street Directory* of 1855 with S. Wilcox in charge. The lawns have been built up around it in recent decades, giving the false impression of a low tower. The original Nimmo plan was for the new railway in the 1830s to be on the land side of the tower, but in fact the railway was built on the sea side of the tower. This tower was bought by Johnson Roberts in 1902 for £250. Blackrock Urban District Council acquired it in 1907, and in recent decades it has been used by Williamstown Football Club as their changing rooms.

In *Thom's Street Directory* of 1850, Seapoint Tower (No 14) in Brighton Vale is listed with Sergeant Craig in charge. The tower was sold to Blackrock UDC in 1901 for £300. In the 1950s and '60s there were tearooms and sweet shops in adjacent huts, catering for the hundreds of sunbathers who flocked here during the summer months. The Genealogical Society of Ireland restored the tower in 2004, but left a few years later. Now the council opens it up to tourists in the summer.

In 1807, the ship *Prince of Wales* was wrecked in a storm, off Blackrock House, and *The Rochdale* was wrecked nearby at Seapoint, with a total of 400 drowning (mostly soldiers). The former were buried in Merrion cemetery (beside the present Tara Towers hotel) and the latter in Carrickbrennan cemetery, Monkstown. Another very sad event occurred on Christmas Eve 1895, when a Finnish sailing ship, *Palme*, ran aground on the Razor Bank opposite Blackrock. The crew were saved by Irish Lights tender, SS *Tearacht*, but the fifteen crew members of Civil Service No. 7 lifeboat from Kingstown (now Dún Laoghaire) lost their lives.

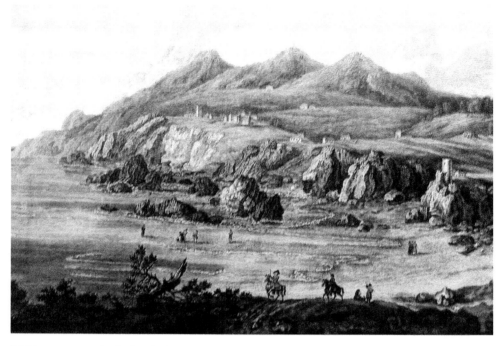

1744 painting of Blackrock by William Jones. The Sugar Loaf mountain is in the background. (Courtesy of the National Library of Ireland)

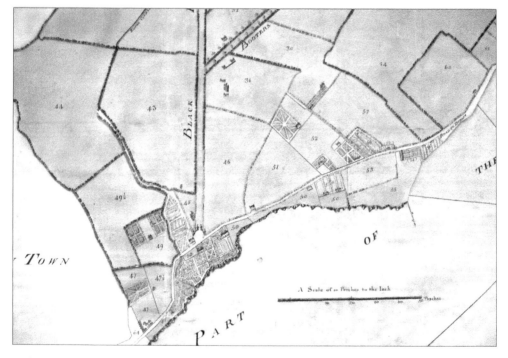

Barker's 1762 map of part of the Fitzwilliam estate. The main road through the centre of the map is the bottom of Mount Merrion Avenue. (Courtesy of the National Archives of Ireland)

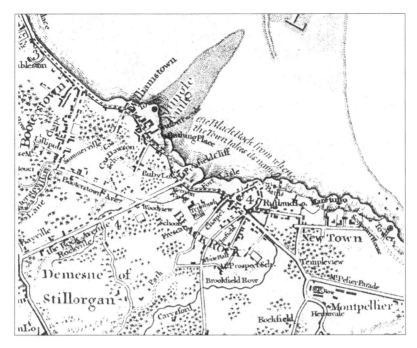

Taylor's map of Blackrock in 1816. (Courtesy of Trinity College Dublin)

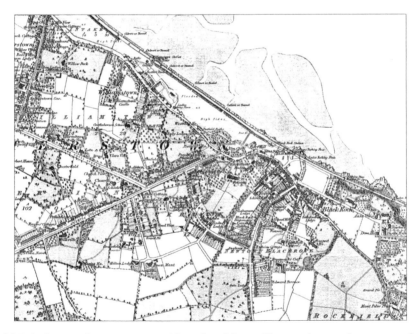

1837 Ordnance Survey extract. Note that Idrone Terrace houses have yet to be built. Castle Byrne House is at the corner of present-day Newtown Avenue and Seapoint Avenue, and it was later called Seapoint Manor. Castledawson School is now part of Blackrock College. (Courtesy of Trinity College Dublin)

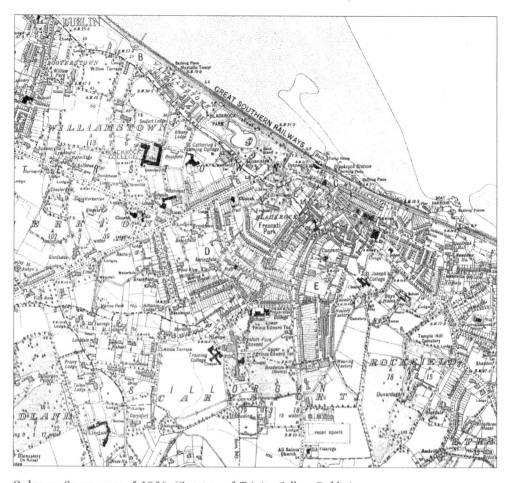

Ordnance Survey map of 1936. (Courtesy of Trinity College Dublin)

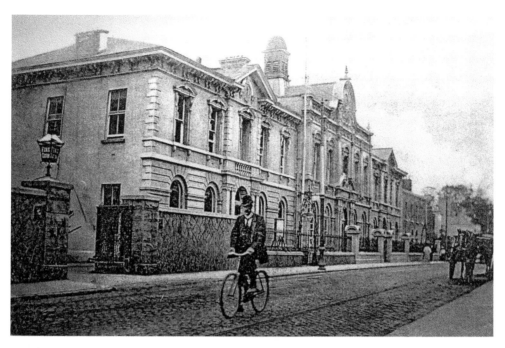

Postcard showing the town hall on the left, followed by the higher Carnegie Library and then the Technical School. (Courtesy of Dún Laoghaire Rathdown County Council)

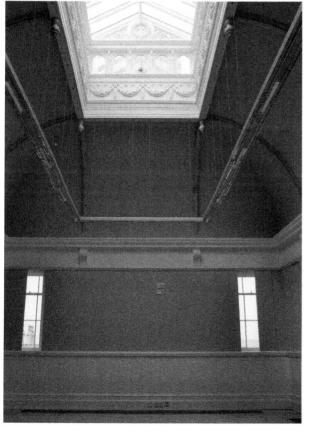

The former town hall council chamber was recreated in 2014 in the former Technical College (now Blackrock Further Education Institute).

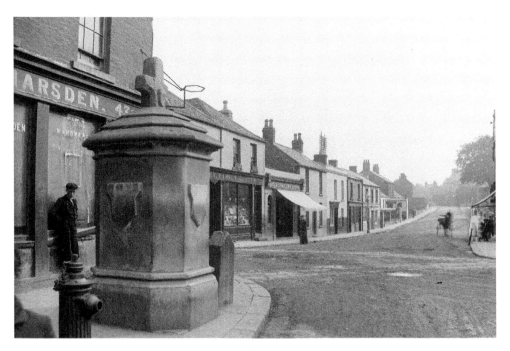

The stone cross (with very large base) outside the present Central Cafe at the city boundary, c. 1900. Note the stone mileage marker beside the cross. The shops here are at the bottom of Carysfort Avenue. (Courtesy of the National Library of Ireland)

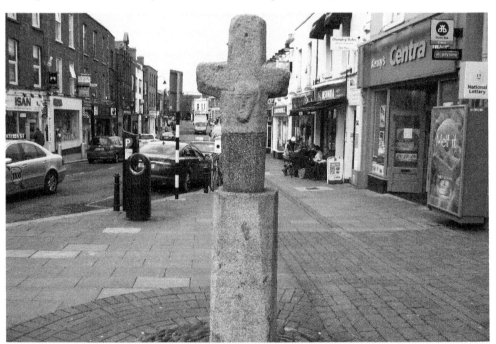

Present view of Blackrock Cross, on a modern pedestal, looking north up Main Street. This is not the correct location for the historical boundary marker.

The former Garda station at 15a Main Street is now the Inland Fisheries Board.

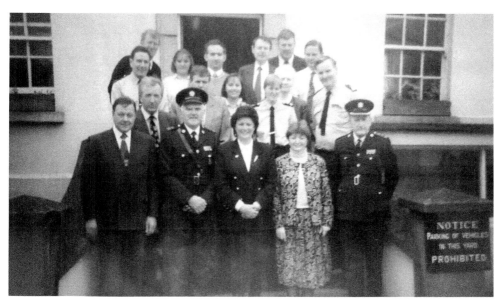

This photo was taken in front of the old Garda station at 15a Main Street in 1994. From left to right, front row: Garda Pat Lydon, Superintendent John Mee, Minister Maire Geoghegan-Quinn, Siobhan Quinn (staff officer), Chief Superintendent Des Malone. Second row: Inspector Felix McKenna, Garda Jim Kane, Anna McTigue (staff officer), Garda Carmel Roberts, Freddy Malarkey (staff officer), Sergeant Fred Healy. Third row: Inspector Liam McCahey, Grainne O'Malley, Garda Jim Daly, Sergeant Peter Logue, Garda Dennis Motherway. Left rear: Garda Jim Duffy. Right rear: Garda Gerry Quinn. (Courtesy of the An Garda Síochána)

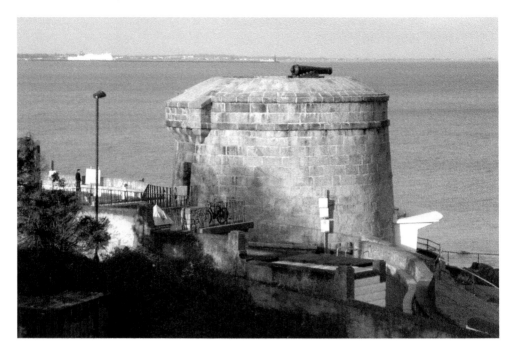

Present view of Seapoint Martello tower, with South Bull Wall in the background.

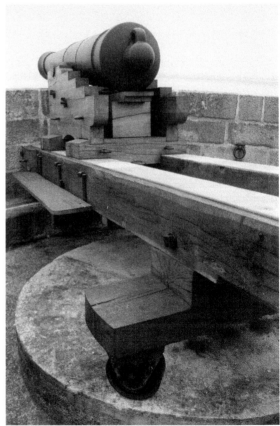

This is a new cannon, on a movable timber carriage, on top of Seapoint Martello tower.

2

EDUCATION

BLACKROCK COLLEGE, ROCK ROAD

The Holy Ghost priests (now called Spiritans), a French order, acquired Castledawson House in 1860 for use as their first boarding school in Ireland. The house was built a century earlier for James Massey Dawson, and was recorded as Castledawson School in 1816. The priests built Immaculate Heart House in 1861 (it was recently demolished), the chapel in 1868, the dining hall in 1873, the Tower in 1874 (with statues of St Joseph, St Patrick, St Peter and St Paul), the Jubilee Hall in 1914, and the new secondary school and swimming pool in 1973.

Meanwhile, they acquired Williamstown Castle in 1875 for use as a Civil Service College (in the days when exams had to be passed to join the Civil Service), but in 1881 changed its primary use to Blackrock University College. This castle was built in 1780 for William Vasasour, and the priests added two side extensions in 1906. In that year they demolished the village of Williamstown, although the side nearest the sea was rebuilt by about 1910.

Nowadays the secondary school, on 62 acres, caters for 2nd to 6th class, with 1,100 pupils and 100 staff. There are still about 100 boarders in Williamstown Castle. There are six sections/houses: De Valera, Duff, Ebenrecht, Leman, McQuaid and Shanahan.

Willow Park is the priests' junior school, feeding directly into Blackrock College, and in fact they share the same playing fields. The house, dating from 1770, opened as a school in 1935 and, following recent extensions, now caters for 600 boys.

Blackrock Rugby Football Club was founded in 1882 by former pupils of Blackrock College. They acquired their first off-site playing field at Nutley (Dublin 4) in 1935. However, in 1945 they built a pavilion at Blackrock, and it was not until 1961 that Somerset House, on 8 acres, at Stradbrook Road, was purchased.

SION HILL, CROSS AVENUE

Sion Hill girls' school was founded by Dominican nuns in 1836, with eight boarders, forty day pupils, and ten nuns. The old three-storey house had six main rooms, plus servants' rooms, porch, conservatory, and stabling. A large new school, incorporating a first-floor chapel, was erected in 1850 in front of the old house, and called St Catherine's – this was extended at right-angles in 1928 to incorporate

a concert hall on the ground floor, with classrooms overhead. Boarding ceased in the 1960s to free up space for new pupils, when free secondary education was introduced by the government in 1967.

St Catherine's College of Education for Home Economics started in 1910 in Abbeyville (site of the present modern school entrance block), moved to Melrose in 1912 (rear of recent Froebel College), and then in 1925 to Ruby Lodge. In 1935 a large extension was added, noticeable by its greenish mansard roof. This college closed in 2007, and the building is now leased to the adjoining Blackrock Clinic.

In 1936 a junior school was built alongside Cross Avenue, but was converted into Froebel College of Education in 1943 (for teacher training). However, in 1933/34, the nuns organised the country's first six-month Montessori Teacher Training Course in Sion Hill, and the Froebel College followed on from this. In 2013, Froebel College in Sion Hill closed and moved to Maynooth in County Kildare (now known as Froebel Department of Primary and Early Childhood Education).

St Raphael's College of Physical Education, with its gym, was built by the nuns in 1957 to the rear of the present convent. It is now a public Adult Education Centre.

The 1901 Census recorded sixty-one boarders (aged 6-19, but mostly older girls), twenty-five nuns, two cooks, eight housemaids, and one servant, under the charge of Sr Mary Elliott. The 1911 Census records ninety boarders (aged 7-19), thirty-one nuns/teachers, and twelve staff.

Nowadays there are 320 girls in the school, and the girls team up with the boys of Oatlands College in Stillorgan for their annual musical in the Sion Hill Concert Hall (Blackrock boys team up with Mount Anville girls for their annual musical). The nuns' private chapel, and the girls' larger chapel in the 1850 building, are now the school library. A new convent has been built for the nuns, but they still retain the detached tiny Sacred Heart oratory in their rear garden, built in 1872, and incorporating white marble wall panelling, marble altar, and a stained-glass window – the oratory is opened only once a year.

Over the life of the school, various old houses were demolished to make way for new buildings. In 1989, 6 acres of hockey pitches were sold to a housing developer, by Emma Wilson, Leslie Mangan, Bridget Hourigan and Roisin O'Nolan (these are not their religious names) for £2.5million, and an estate called Sion Hill was built within two years. In 2005, the nuns (now represented by Olive Hetherton, Monica Pender and Kathleen Moran) sold a 0.555 acre site for a multi-storey car park to Blackrock Clinic (James M. Sheehan, Joseph Sheehan, George Duffy, and Hestow Ltd) for €4 million, but retained their cemetery, which is still used. The road in/out of the car park belongs to the nuns, and the clinic has right of way.

UCD SMURFIT BUSINESS COLLEGE, CARYSFORT AVENUE

The Sisters of Mercy were based in Lower Baggot Street from the 1830s, and operated a girls' national school in that period. In 1877 they built Sedes Sapientiae (Seat of Wisdom) Training School beside the convent, to train nuns as national school teachers for government-funded schools. This was renamed Our Lady of Mercy Training College in 1883.

In 1891, Mother Ligouri Keenan bought Carysfort Park house and estate from Baron Deasy, and the following year a few nuns from Baggot Street were sent here. This splendid late-Georgian house was occupied in the early years by the Saurin family, and by the Deasy family from 1866.

By 1895, the nuns had built their red-brick novitiate and chapel beside the convent, in addition to a government-funded St Mary's Industrial School for Girls (a fancy name for an orphanage) to the north of the chapel. In addition, they built a national school in Prince Edward Place (the present Convent Road), which officially opened on 22 November 1895.

In 1901, the nuns started building a new teacher training college immediately to the north of the industrial school, and the Baggot Street College moved here in 1903. Meanwhile, the girls in the industrial school were moved to St Anne's Industrial School in Booterstown Avenue (beside the present Catholic Presbytery), and also to Goldenbridge Industrial School in Dublin, both run for the government by the Mercy nuns. The former industrial school in Carysfort became part of the new Teacher Training College.

The nuns' next venture was to build a Junior Preparatory College (JPC) in 1906, right beside their national school on the present Convent Road, which prepared teenage girls for the entrance exams to Our Lady of Mercy Training College. This usage continued until 1947 when the JPC became dormitories for the college – an oratory and infirmary were added in 1961.

In 1932, the hall of residence was built behind the college for student nuns only, but was made available to lay students in the 1970s. The college achieved university status in 1975, when men were admitted, and a B.Ed awarded after completing the 3-year course. Around 800 students attended the college annually. The nuns always retained their Georgian convent and 1895 novitiate to the south of the chapel.

Because of a temporary fall in birth rates, the government rashly ordered the closure of the college in 1988, when Sr Regina Durkan was the last president. The 90-acre estate, including a separate farmyard, was sold almost immediately by the Mercy nuns for £20 million, and part developed by the new owner as a housing estate, with a public park created, including the lake. Surprisingly, State-funded University College Dublin (UCD), which has its extensive campus in Belfield in Donnybrook, bought the college and 19 acres from the new owner in 1990 for £8 million, and converted the buildings into the Smurfit Business College.

In the Smurfit UCD College, the lovely chapel with stained-glass windows by Meyer of Munich and the Joshua Clarke Studios in Dublin, has been converted into the student's library, including a new mezzanine floor. The former JPC was added to Carysfort National School in 1998, but is still owned by the Mercy nuns – the adjacent single-storey former oratory and infirmary are used as their accounts office.

The all-Irish Scoil Íosagáin secondary school was started by the Mercy nuns in the single-storey extension (built 1932) at the west end of the national school in 1971, before moving in 1984 to its present home on the Stillorgan Road, adjoining the all-Irish Colaiste Eoin, run by the Christian Brothers, beside St Helen's Radisson Hotel.

Carysfort College's claim to fame is that Eamon de Valera, who would later become President of Ireland, was professor of maths here from 1906 to 1916.

The 1901 census records 136 residents in Carysfort College, comprising forty-four nuns, seventy-four children in St Mary's Industrial School (mostly aged 6-15), and eighteen boarders (aged 18-21). The 1911 Census records 200 student nuns, and fifty-five teacher nuns, under Sister Mary Bourke.

MEATH INDUSTRIAL SCHOOL FOR PROTESTANT BOYS, CARYSFORT AVENUE

The first meeting of the trustees (including the Earl of Meath, Kilruddery, Bray, County Wicklow) of this boys' orphanage was held in 1871 in the Protestant Industrial School for Girls, Heytesbury Street (in the former Courthouse/Marshalsea of St Sepulchre, at the corner of Camden Row, opposite the Meath Hospital), and they decided to rent Elmcliff House (to the east of Lios an Uisce, but the land is now part of Blackrock Park) for five years from 1871. The orphanage opened on 9 May 1871, and nineteen boys (up to 16 years of age) were received in the first year. James Wilson was the first manager, followed by John Treanor. It should be noted that Artane Industrial School in north Dublin had only opened in July 1870, but was for Catholics. At that time, other Protestant orphan boys were sent to a ship (a floating industrial school) called *Gibraltar* in Belfast, for Royal Navy training.

The trustees built a fine new granite-faced school on 10 acres in Carysfort Avenue in 1876 (but not occupied until 1877), adding a north-east extension around 1886, and the south-east extension (with veranda) in 1910. The east wing of the detached infirmary at the north-east corner of the campus probably dates from the 1880s, and the west wing was probably built around 1900. The detached gym on the west side of the campus was built in 1894.

A government report of 1878 on the Meath Industrial School records fifty-one boys (called 'inmates') in the new residence. Seven boys had absconded from Elmcliff in 1877 – all were captured, and one was sentenced to imprisonment of one month (adult prison), three sent to a reformatory (boys' prison), and three re-admitted. Tailoring and shoemaking were taught (the boys made their own clothes and shoes, and the rest was sold to the public) and they did housework, cooking, laundry, and worked on the farm. A workshop for carpentry and cabinet-making was proposed. The teacher taught reading, writing, grammar, dictation, composition, arithmetic, geography, and English history. The staff comprised Dr S. Gordon (Secretary), Mr and Mrs Vanston (master & matron), an assistant-master (teacher), a tailor, and a shoemaker.

The 1901 census records: Robert Adderley (aged 30) as master, Henry Johnson (aged 30) a teacher, John Mansfield (aged 27) is another teacher, Harriott Ross (aged 28) is the matron, Annie Perry (aged 27) is the nurse, and 111 boys, generally from Dublin, mostly aged 11-15, with a few younger, including two Smith boys (aged 3 and 4) from Monaghan. When the Protestant Industrial School in Cork closed in 1902, the boys were transferred to Blackrock in Dublin. Hence, the 1911 Census lists 137 boys, John R. Beeby as manager, his wife as matron, two schoolmasters, one needle mistress, a laundress, and a cook. The records of nearby All Saints' National School list twenty-six boys from the Meath Industrial School in attendance 1902–1909, obviously the extra intake from Cork.

A 1914 government report records ninety-nine 'inmates' (eight were voluntary, others committed by courts), manager and matron (Mr and Mrs J.R. Beeby), head schoolmaster, assistant master, carpenter, tailor, shoemaker, gardener, cook, laundress and needle mistress.

Towards the end of the First World War the school was leased by the British War Office and, no doubt, many of the boys were sent off to the British Army. The school contents were auctioned by Hazley & Co. in March 1917, including the

brass instruments of the school band (just like the Artane Boys Band, the Meath Boys Band performed at various public events). The army survey in 1917 for new electric light and power gives the uses of the various rooms. The ground floor contained three interlinked classrooms at the west end, manager's rooms in the centre, and a dining hall (44 feet by 38 feet) next, with kitchen beside. A technical school and masters' room were off the front veranda. The first floor had mostly large dormitories (A-F), generally open plan and interconnected, in addition to a carpenter's shop on the first floor annex (above the kitchen stores). There was a detached gymnasium and laundry at the north-west of the campus (beside the two-storey gate lodge), with communal bathrooms and wash basins over the laundry. To the north-east of the main building, there was a tailor's shop, a shoemaker's shop, a lathe room, and glasshouses. An isolated, T-shaped small infirmary/hospital was at the extreme north-east of the campus.

The school buildings were converted into a Military Orthopaedic Hospital in 1917, to cater for injured soldiers sent from Europe and further afield. A small single-storey operating theatre block was built just to the north of the old building. Thirteen detached ward huts were built, very basic single-storey prefabs – generally 60 feet by 20 feet, 7 feet 3 inches to eaves, and 11 feet to ridge, and one central stove. The old north-east Infirmary was converted into the officers' mess (dining room), and a separate prefab ward built nearby. The Red Cross and the YMCA were provided with their own blocks. The gym was converted into a massage room, one building was provided for making artificial limbs, and at the very south-west of the campus, a bowling green was laid out. In total, the hospital could accommodate twenty injured officers, 500 non-commissioned officers and soldiers and thirty-four staff (including four NCOs). A high-level electric cable was taken from the power plant in the Tram Depot on Newtown Avenue in the village.

British Pathé News produced a short film in 1921 about this hospital in which a man displays his skill at carpentry, using his artificial arm – the film can be watched for free on their website.

After the war, the Ministry of Pensions ran the hospital. It was sold in 1932 and some patients transferred to Leopardstown Park Hospital. Benjamin McKinley then bought the complex and lived in the north annex of the original orphanage, letting the orphanage as flats (called Avondale Hall). Bradmola Hosiery Co. moved into the gym in 1934, while Apex Hosiery Co. built a new factory to the east of the orphanage, and Rycraft Hosiery Co. used a small block to the north of Apex Hosiery. Johnson & Johnson occupied the old operating theatre in the 1940s. J.E. O'Brien & Sons (food flavours) were in part of the gym building in the 1950s, before moving to the former Apex building, and in the 1970s became the first occupier of the greenfield Sandyford Industrial Estate. Jefferson Smurfit & Sons Ltd was in part of the Avondale Works in the 1960s. The Avondale housing estate to the south of the orphanage was built around the same time.

No. 18a Avondale Lawn (now called Ladymead, but was Willow Cottage) was the former infirmary, and then the officers' mess, and the Glaslower stream still flows through this charming property into the adjoining Rockfield Park. The original 1880s infirmary block has narrow windows, while the right-angled extension seems to date from around 1900.

When the 1.5-acre estate was sold around 1984, Parle & Hickey Ltd occupied part of the main building, Benedict Imports Ltd occupied another part of the main building, and the rest comprised five apartments (four occupied). Dublin Crystal

Glass Co. Ltd occupied 5,807 square feet in the north part of the former gym. The attractive Walnut Lodge was occupied, and comprised a living room, dining room, kitchen, two bedrooms, and a bathroom.

In recent years, office blocks have been built alongside Carysfort Avenue, replacing the Bradmola factory block and Walnut Lodge, but the original granite orphanage and the Apex factory await new uses.

There was also a Meath Industrial School for Protestant Girls in Bray, initially in Oldcourt in 1872, then in Templecarraig from 1888, and finally a new attractive building in Vevay Road in 1892 (near the town hall). During the last two years of the First World War, the orphanage was converted into the Duke of Connaught Auxiliary Hospital, run by the Red Cross for wounded British soldiers. From 1920, the building was used as the Royal Drummond Institution for orphan daughters of British soldiers. In 1944 the Loreto nuns bought the building and converted it into St Patrick's National School, which is still going strong. When the Meath School in Heytesbury Street was rebuilt as a hospice (Gascoigne Home) in 1903, the girls were transferred to the Bray Meath School. The Meath Industrial Schools, and the many others throughout Ireland, were government funded, although also sought subscriptions from the public.

The records of the Meath Industrial School, including registers of boys and minutes of meetings, are held in the RCB library in Churchtown.

DAUGHTERS OF CHARITY, DUNARDAGH, TEMPLE ROAD

Craig More was designed in 1863 by John McCurdy for William Hogg, and occupied by the Martin family (of T&C Martin, builder's providers) in 1915. The house was bought in 1925 by the Daughters of Charity, a French order, and renamed St Therese (now St Theresa), being used as a boys' (aged 3-10) orphanage until 1959, when the boys were transferred to St Philomena's, Stillorgan. In the 1950s, District Justice MacCarthy made an annual appeal for money, on behalf of St Therese's Boys Home, on Radió Éireann (usually 6.45–6.50 p.m.). After 1959, the nuns reused the house as a home for girls with mild mental disabilities, being an extension of Holy Angels, Glenmaroon, beside the Phoenix Park. A purpose-built school was opened in 1969, after the chapel was demolished. The school closed in 1987, and the girls were sent to Glenmaroon. In 1988, forty women with moderate learning difficulties were transferred from St Vincent's, Navan Road, to St Therese, but these days, the property is empty.

From 1932 to 1939, part of St Therese was a novitiate/seminary. In 1939, the adjoining Dunardagh, on 40 acres, was purchased by the nuns as their novitiate, St Catherine's. This 1860s house, built by George Orr Wilson, was occupied by Lady Fitzgerald-Arnott from around 1904. The nuns immediately sold a field to the local authority, who in turn built St Vincent's Park (forty bungalows) adjoining Temple Hill. The convent was extended in 1950, including a chapel. In 1965 the nuns sold some land for a new parish church and primary school on Newtownpark Avenue (Guardian Angels), and also sold some land to the local authority, who in turn created a park and football pitches (Rockfield Park). Single-storey Rickard House, adjoining St Catherine's Convent, was built in 1982 as a nursing home for the nuns. Now the convent is the Provincialate, and also used for retreats.

Under the Residential Institutions Redress Act 2002, the Daughters had a liability for €7,805,832 (but a blanket indemnity from the State). In 2003, they

transferred a site of 1.2 acres near St Teresa's, to Dún Laoghaire Rathdown County Council for free, thereby reducing their liability to the State by £2.4 million (€3 million). The county council used the land to build an estate for Travellers, comprising two detached and four semi-detached bungalows, called St Louise Park. Also in 2003, the nuns transferred the walled garden of St Teresa's (also 1.2 acres) to the Alzheimer's Society of Ireland, for €1, thereby knocking another €3 million off their debt to the State. The society built a nice day care and respite centre in 2008 called The Orchard, retaining the old brick garden walls.

ST JOSEPH'S COLLEGE, BARCLAY COURT, TEMPLE ROAD

The Vincentian priests (who are devoted to St Vincent de Paul) are also called Lazarites, or the Congregation of the Mission (CM). They currently run All Hallows' College in Drumcondra, Castleknock College, and St Paul's College in Raheny. They previously ran St Patrick's College of Education in Drumcondra, and St Peter's church in Phibsboro is also owned by these priests.

The Vincentians bought St John's in 1873 and renamed it St Joseph's Novitiate. (The house had been called Prospect in the late Georgian period.) The priests added a new college and chapel in 1887, and extended the college northwards in the 1930s. Prefabs were erected in 1967, for residential retreats for local schools. Farming ceased in 1972, and the property, on 11.25 acres, was sold in 1978 for £485,550. The priests moved to a purpose-built seminary in Celbridge, which was sold in 1988 to the Brothers Hospitallers of St John of God.

The new owner of St Joseph's built a small housing estate on part of the land, called Barclay Court. The old house survived, although the chapel and college were demolished. Rosemont School had just been founded by a group of lay people, under the patronage of Opus Dei, and they adapted the old house as a girls' private secondary school. Rosemont moved to a new building in Sandyford (beside Fernhill Gardens) in 2012, and leased the old Blackrock building for two years to the International School of Dublin as a mixed primary School.

During their time in Blackrock, the priests also worked as chaplains to the Mercy nuns in Carysfort College (now UCD Smurfit), and to the Carmelite nuns in Sweetmans Avenue (now the Hospice).

The 1901 Census records thirty-six residents in St Joseph's, comprising six priests, one visitor, seven lay brothers, and twenty-two students (all in their twenties), with Fr Thomas Morrissey as head. The 1911 Census records eleven priests and staff, five professors, and fourteen students.

NEWPARK COMPREHENSIVE, NEWTOWNPARK AVENUE

This well-known mixed secondary school is State owned but under Church of Ireland patronage, and is an amalgamation of Avoca School in Blackrock and Kingstown Grammar School in Dún Laoghaire, founded in 1891 and 1894 respectively.

Kingstown Grammar School was started in 41 York Road in the old Scots Presbyterian church by M. E. Devlin.

Avoca School, meanwhile, was started in 2-4 Sydney Avenue by 25-year-old Albert Augustus Mac Donogh and his brother Irwin. By 1900, the school had

moved to 'Whitehall', a Victorian house at 74 Carysfort Avenue (now demolished and replaced by Blackrock Business Park/An Post sorting office).

Mac Donogh remained as headmaster until 1934, and was replaced by the progressive Cyril and Cerise Parker, who immediately moved Avoca School to the red-brick Belfort on Newtownpark Avenue. The adjoining Melfield was acquired in the 1950s. When Cyril died in 1962, Michael Classon took over, amalgamated with Kingstown in 1968, and renamed the school Newpark Comprehensive in 1972, after it was sold to the Department of Education for £100,000.

In 2014, Newpark built a new school on their site, and now cater for about 480 boys and 350 girls. The Avoca Hockey Club is still going strong.

BOOTERSTOWN NATIONAL SCHOOL (ST PHILIP & ST JAMES), CROSS AVENUE

This homely mixed school has its origins in 1826, when it was located to the east of the new Church of Ireland church (built in 1824). The old parish hall was later built immediately to the south of the school. A new school was opened in 1957 in the church driveway off Mount Merrion Avenue. In recent years, the old school and parish hall, in addition to the lodge, were demolished to make way for a Barrett Cheshire nursing home. The new church hall (Carysfort Hall) was built in 1967 to the south of the present home.

BLACKROCK NATIONAL SCHOOL, TEMPLE ROAD

The Pettigrew & Oulton Street Directory of 1835 records a male and female national school on Back Road (now called Temple Road). Maps of that period show the school just to the south of the present St John the Baptist church, although the school appears to have been built in 1822. Sr Columba, a Mercy nun, was principal in 1891.

After 1895, Blackrock National School was for boys only, when the Mercy nuns girls' school opened on present Convent Road.

In 1926, a new boys' school was built to the south of the church for 170 boys, comprising five classrooms, and built of granite, designed by J.J. Robinson. The original national school was demolished in the 1930s, to allow the present church steps to be built.

The new school closed in 1980, and was later demolished to make way for three office blocks (Avoca Court, etc). The boys transferred to the Mercy Girls' National School in Convent Road – see section on UCD Smurfit College.

TECHNICAL SCHOOL, NEWTOWN AVENUE

The Department of Agriculture and Technical Instruction set up Technical Instruction Committees all over Ireland in the opening years of the twentieth century, to provide technical second-level education. The Blackrock Committee was formed in March 1901, when William Field (who was an Urban District Councillor) was elected chairman. Their first premises opened in September 1901, in Clermont House on Rock Hill (now the site of modern shops and the Dart car park), and they

offered day and evening classes in building, tailoring and dressmaking, bookkeeping, cooking, laundry work, etc. Alexander Hill from Birmingham, a Presbyterian, was the first headmaster. The technical school later became the source of many employees for the Blackrock Laundry, and the various hosiery factories which set up in the locality in the 1930s, such as Blackrock Hosiery Co., Bradmola Hosiery Co., etc.

Their new school opened in September 1905, at the same time as the newly built Carnegie Library, in Newtown Avenue. George O'Connor was the architect of both buildings, which have elaborately moulded sand/cement front elevations, matching the adjoining town hall. The architect certainly got it badly wrong, as he made the new Carnegie Library the dominant building in the convoluted threesome, when in fact the town hall should take centre stage.

In 1930, the Technical Instruction Committees of Blackrock, Dalkey and Dún Laoghaire amalgamated into Dún Laoghaire Vocational Education Committee (VEC).

Blackrock Technical School closed in 2006, and moved to Senior College Dún Laoghaire (SCD), Eblana Terrace, under the control of the VEC (now called the Education and Training Board – ETB), where it operates as a bridge between second and third-level education.

The old college in Blackrock has recently been redeveloped, in conjunction with the adjoining library and former town hall, and the SCD reopened in September 2014 in part of the new development, rebranded as Blackrock Further Education Institute (BFEI).

The Carnegie Free Library opened alongside the town hall in 1905, assisting in the provision of an Assembly Room for 400 people. Andrew Carnegie was born in Scotland, and after his family emigrated to America, he made a fortune in the steel business, especially railways and bridges. He set up trusts to distribute his wealth all over the world, and is most famous for grant-aiding thousands of public libraries. About eighty Carnegie libraries were built in Ireland at the beginning of the twentieth century, all of different designs and sizes. Blackrock library is plastered externally with sand/cement, but richly embellished in the same material.

OTHER SCHOOLS AROUND BLACKROCK

Rockford Manor (Stradbrook Hall) was started in 1958 by the Presentation nuns, as a secondary school for girls, and now has about 300 pupils.

All Saints' National School was built in 1879, at the corner of Stillorgan Park and Carysfort Avenue, and is still going strong. The adjoining teachers' house was sold in 2007, and now houses the Blackrock Veterinary Clinic.

Christ Church National School, Carysfort Avenue, dating back to the early nineteenth century, was in the grounds of the Anglican church, but demolished in 1966. It is now the public car park beside Zurich Insurance.

Carmelite National School, Sweetmans Avenue, was part of the Carmelite convent in the early nineteenth century. It is now the site of the Blackrock Hospice.

Guardian Angels, Newtownpark Avenue, opened in 1970 and was rebuilt in 1999.

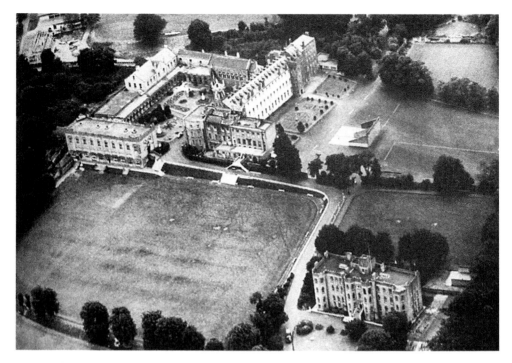

An aerial view of Blackrock College, with Williamstown Castle at lower right, 1950. (Courtesy of the National Library of Ireland)

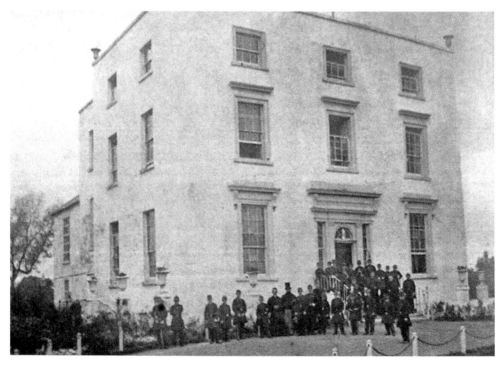

Castledawson House, 1866, the start of Blackrock College. (Courtesy of Blackrock College)

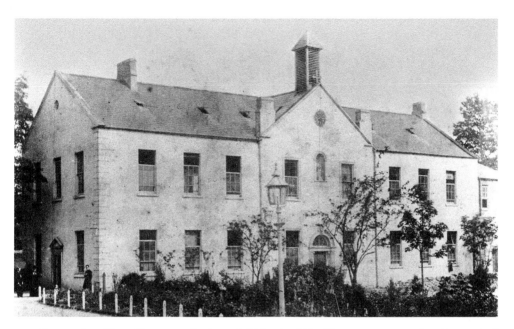

Immaculate Heart House was built in 1861 by the Holy Ghost priests, just after they started Blackrock College, but was demolished a few years ago. (Courtesy of Blackrock College)

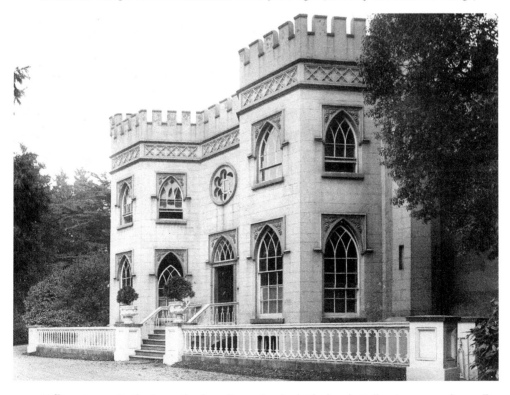

Williamstown Castle (now the boarding school of Blackrock College) was much smaller before being extended in 1906. (Courtesy of Blackrock College)

Williamstown Avenue houses were demolished by the Holy Ghost priests in 1906. Note Williamstown Castle in the distance. (Courtesy of Blackrock College)

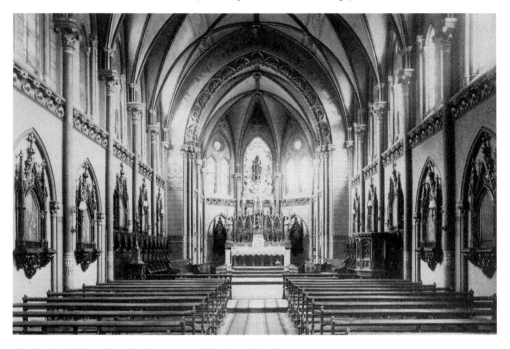

Blackrock College chapel. (Courtesy of Blackrock College)

The Nile Room in Castledawson House was painted in 1909 by Br Fulbert Heim, a German, when it was in use as the oratory. It is now a parlour.

Fr Michael Kennedy reviews the Local Defence Force (LDF) guard of honour in 1942. (Courtesy of Blackrock College)

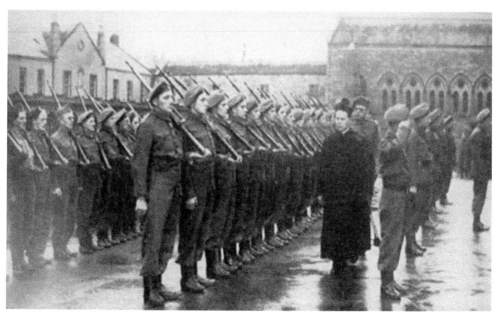

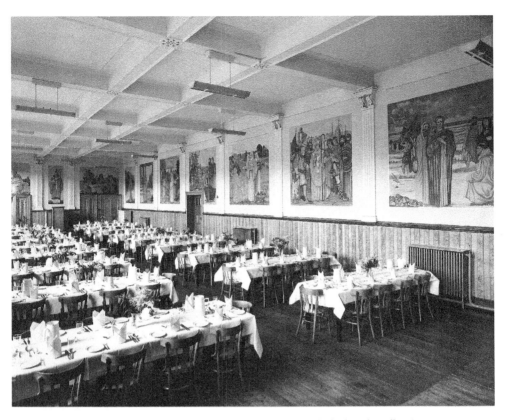

Students' dining hall in Blackrock College, 1954. (Courtesy of Blackrock College)

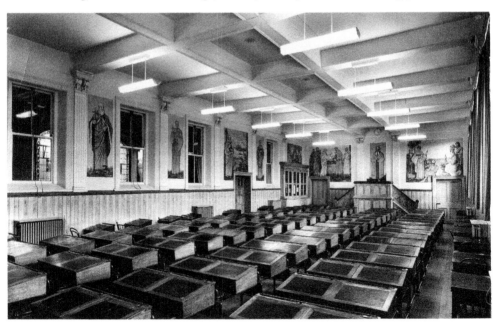

Students' study hall, Blackrock College, 1954. (Courtesy of Blackrock College)

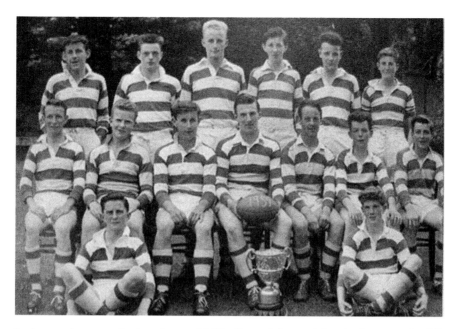

Junior rugby cup-winning team, 1959. From left to right, back row: G. Gill, W. Prendergast, D. Keegan, J. Blunden, F. Convery, B. O'Brien. Middle row: R. Cumiskey, P. Murray, D. Gill, D. Roughan (Captain), J. Quirke, D. Robinson, E. O'Beirne. Front row: J. Regan, J. Dillon. (Courtesy of Blackrock College)

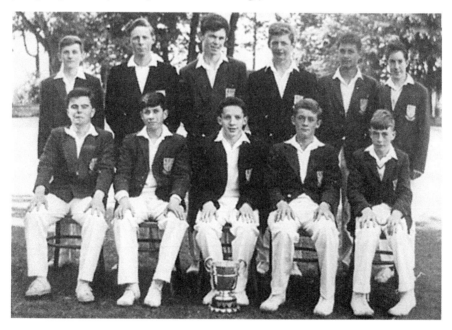

Junior cricket team, 1962. From left to right, back row: Oliver McMahon, Patrick Briscoe, Anthony Amoroso, David Cantrell, Leonard Jones, Timothy Crowe. Front row: Richard Johnson, Paul Grose, Michael Moriarty (Captain), Seamus Power, David Brophy. (Courtesy of Blackrock College)

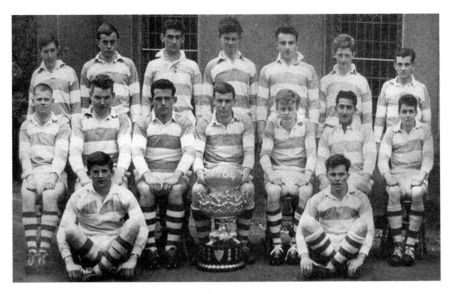

Golden Jubilee cup-winning team, 1964. From left to right, back row: Timothy Crowe, Ruari Quinn, Hugo Hynes, Anthony Amoroso, Peter Canavan, David Cantrell, Derek Scally. Middle row: Raymond Naughton, Michael Whelan, Cornelius Mullan, Brian McLoughlin (Captain), David Browne, Peter Labib-Michael, Sean Kelly. Front row: Liam Hall, Richard Johnson. (Courtesy of Blackrock College)

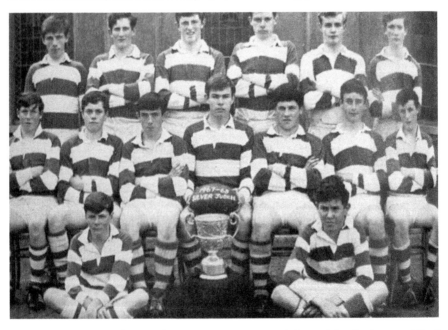

1968 Junior Rugby Silver Jubilee Cup winners. From left to right, back row: Alfred Stone, Joseph Cahill, Terence Sweeney, Daniel Lang, Michael O'Sullivan, Connell Dorris. Middle row: Francis Barnett, Henry Crowley, Colm Henry, Paul Waldron (Captain), John Moran, Desmond Rogers, Liam Quirke. Front row: Peter Forte, James Crowe. (Courtesy of Blackrock College)

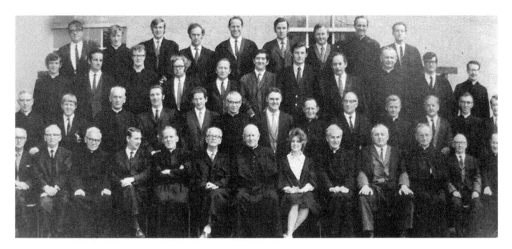

Teaching staff, 1971. From left to right, back row: F. McDonald, P. Kelly, G. O'Connor, P. O'Driscoll, N. Turley, J. Burns, S. Byrne, Fr J. Farrell, S. Cronin. Third row: G. Browne, V. Connolly, B. Starken, D. Murphy, D. Clarke, H. Macklin, D. Marren, P. O'Shea, Fr J. Devine, B. O'Keefe, Fr H. Boyle. Second row: Fr J. Corless, W. Crooks, Fr P. Holly, C. Murray, P. McDonagh, Fr T. Byrne, J. Powell, Fr S. Lodge, J. O'Connor, Fr J. Fullen, F. O'Hanlon, Fr Sean Farragher, J. Waldron. Front row: J. Coyle, R. Murphy, Fr E. Holmes, P. O'Connor, Fr J. Godfrey, T. Coppinger, Fr T. O'Driscoll, Miss A. Molloy, Fr J. Ryan, J. McMahon, Fr M. O'Carroll, W. Browne, Fr P. McMahon. (Courtesy of Blackrock College)

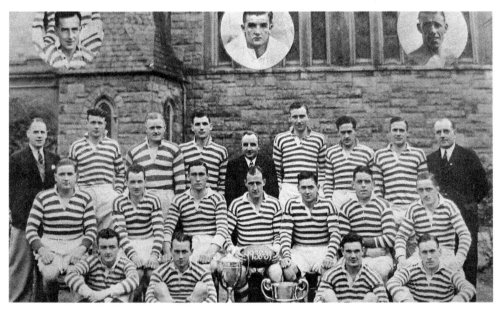

The famous 1939 team from Blackrock College RFC which won the Leinster Cup and the Bateman Cup. From left to right, back row: C.H. McCorry, I. Healy, A. Moroney, J. Hughes, W. Corrigan, K. Keenan, J.K. English, T. Kenny, P.F. Ryan. Middle row: M.J. Delaney, D.G. O'Leary, S.A. Morrison (Vice-Captain), L.B McMahon (Captain), P. Crowe, J.J. Westby, P. Vahey. Front row: L. O'Brien, B. Dunne, J. Ferris, T. Brophy. Inset: B. Bergin, J.J. O'Connor, J. Cullen. (Courtesy of Blackrock College)

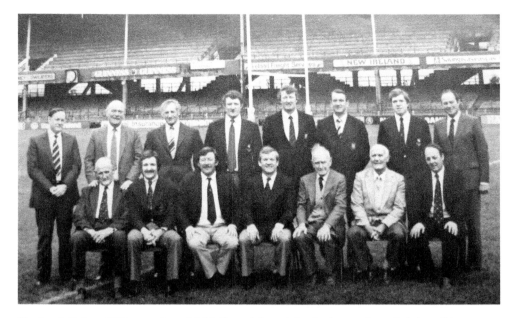

Blackrock College RFC committee, 1982. From left to right, back row: Sean Quinlan, Skinny Dolan, Ray McLoughlin, Ned Byrne, Willie Duggan, Niall Brophy, Fergus Slattery, Noel Turley. Front row: Larry McMahon, John Cantrell, Mick Doyle, Locky Butler, Phil Crowe, Tom Chamberlain, Johnny Quirke. (Courtesy of Blackrock College)

Willow Park House became the Junior School for Blackrock College in 1935. (Courtesy of Blackrock College)

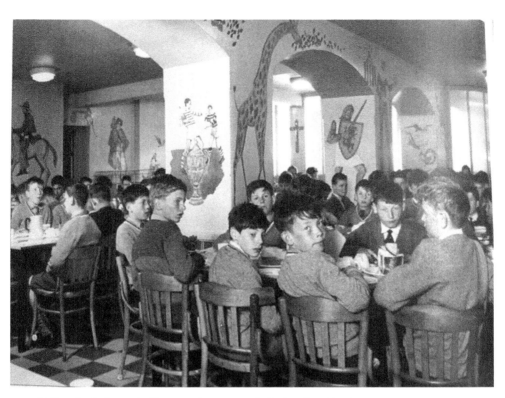

Willow Park dining hall, 1954. (Courtesy of Blackrock College)

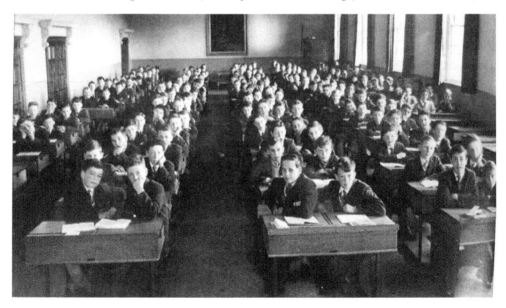

Willow Park study hall, 1954. (Courtesy of Blackrock College)

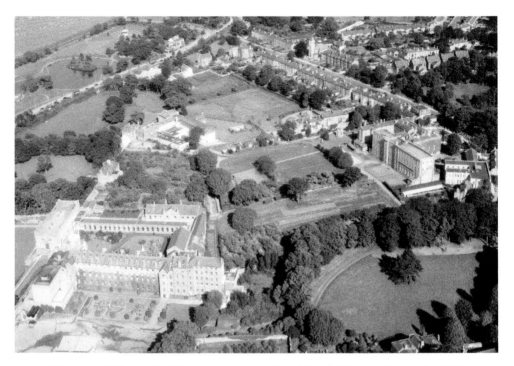

An aerial photo of Blackrock College in foreground, and Sion Hill in background, 1950s. (Courtesy of the National Library of Ireland)

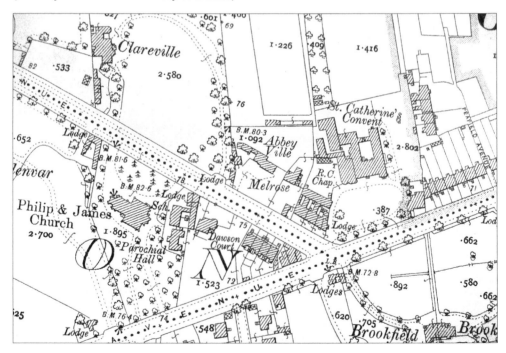

1907 Ordnance Survey map, showing Sion Hill, which included Abbey Ville and Melrose. Clareville was part of Blackrock College, but is now gone. (Courtesy of Trinity College Dublin)

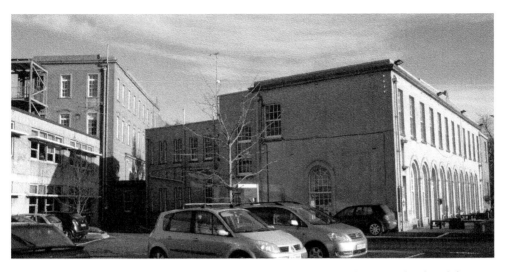

Current view of Sion Hill, with Froebel College on right, and tall 1928 school on left.

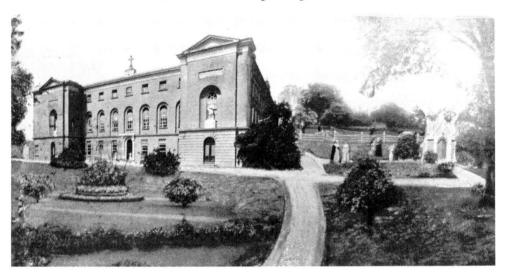

1910 view of Sion Hill, with oratory on right. (Courtesy of the National Library of Ireland)

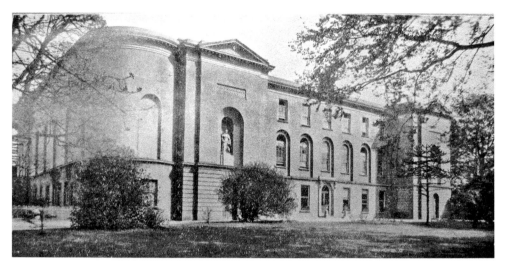

1910 view of Sion Hill, with chapel on left. (Courtesy of the National Library)

1936 view of Sion Hill/St Catherine's Domestic Economy School. (Courtesy of the National Library)

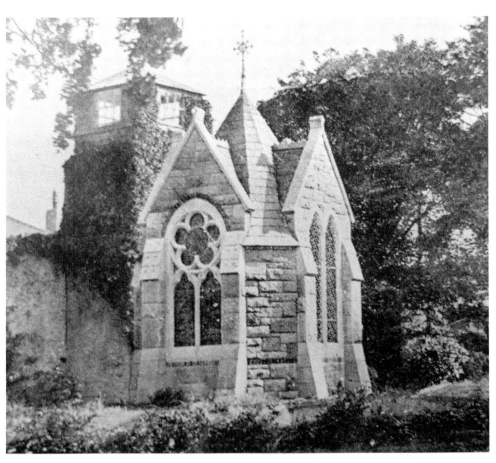

Sion Hill oratory in 1910. (Courtesy of the National Library)

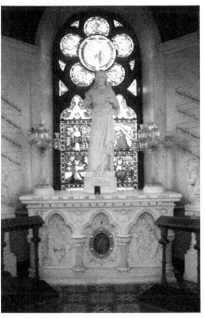

Present interior of Sion Hill oratory.

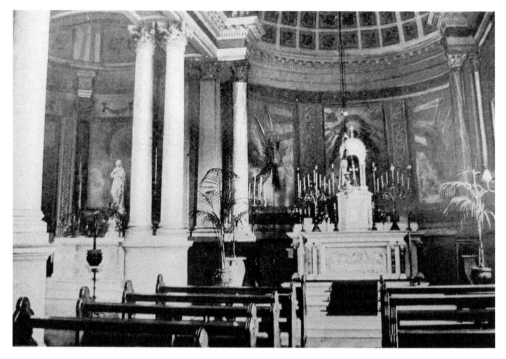

The chapel in Sion Hill in 1910 (now the library). (Courtesy of the National Library)

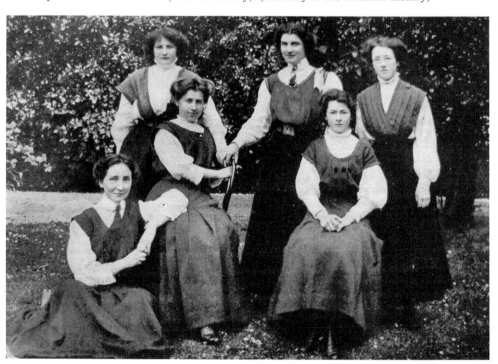

First arts students, left to right: D. Darby, N. Casey, K. Balfe, M. Keegan, E. McEvoy, A. Veale, *c.* 1910. (Courtesy of the National Library)

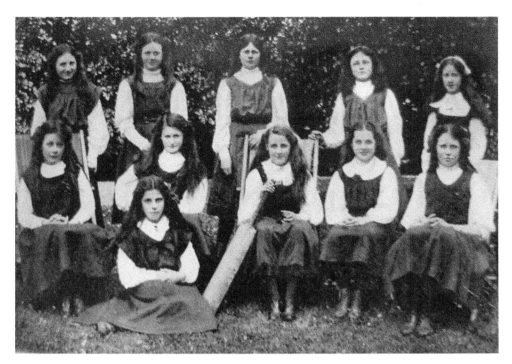

Sion Hill Second Cricket XI, 1914. From left to right, back row: A. Sherry, D. Crinon, F. Coll, S. Coll, A. Wyer. Middle row: O. Rose, E. Redmond, H. O'Reilly, E. Dodd, A. Ryan. Front row: M. Kennedy. (Courtesy of the National Library of Ireland)

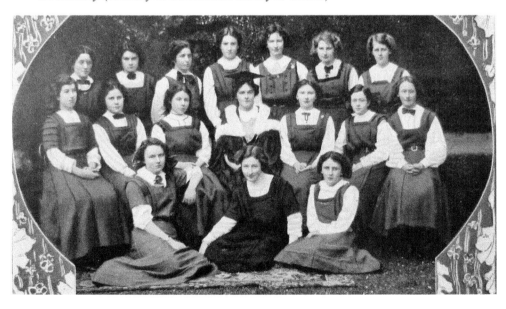

Sion Hill Senior Literary & Debating Society, 1914. From left to right, back row: M. Cleary, M. White, A. Mooney, M. McCann, E. Delaney, T. O'Brien, B. O'Sullivan. Middle row: M. Keenan, E. Bowers, R. Connolly, Miss Dwyer, M. Sexton, G. Huban, M. Ryan. Front row: M. Lemass, A. O'Kelly, V. Flynn. (Courtesy of the National Library)

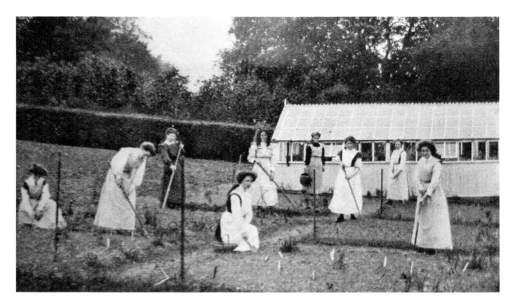

Sion Hill gardening class, 1911. (Courtesy of the National Library of Ireland)

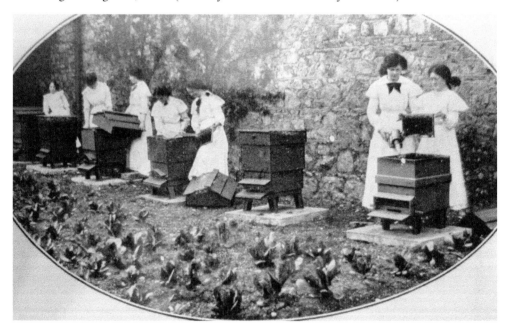

Sion Hill beekeeping class, 1911. (Courtesy of the National Library of Ireland)

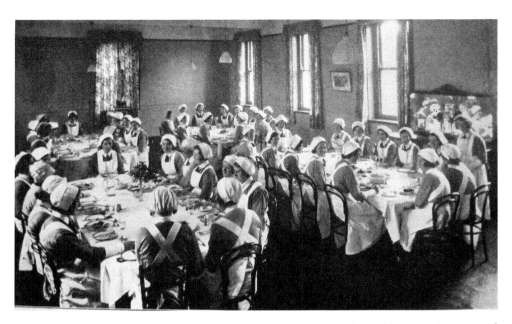

Dining hall of Sion Hill School of Domestic Economy (St Catherine's), 1932. (Courtesy of the National Library of Ireland)

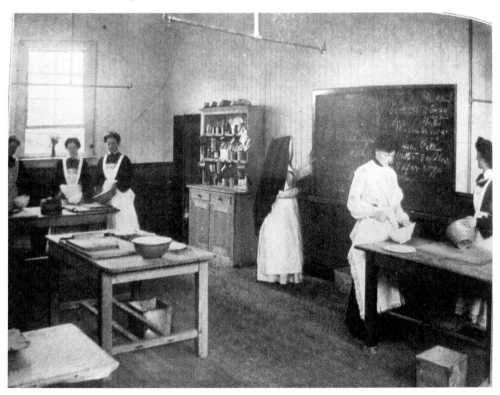

Sion Hill Domestic Economy School, with Dominican nun at the blackboard, 1913. (Courtesy of the National Library of Ireland)

Sion Hill Junior School, 1914. (Courtesy of the National Library of Ireland)

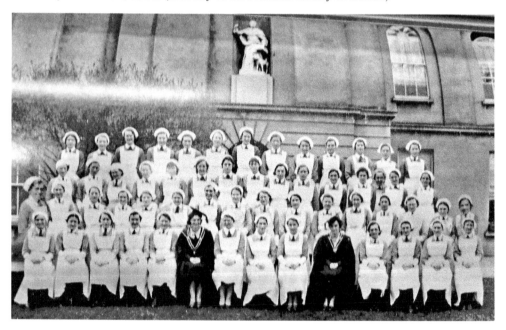

Sion Hill domestic economy class, 1936. (Courtesy of the National Library of Ireland)

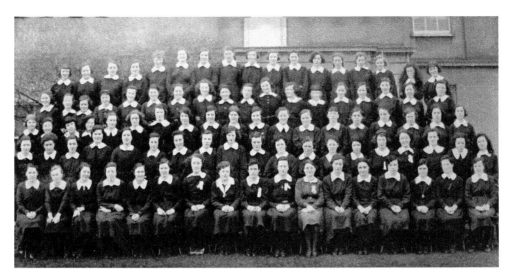

Sion Hill senior class, 1936. (Courtesy of the National Library of Ireland)

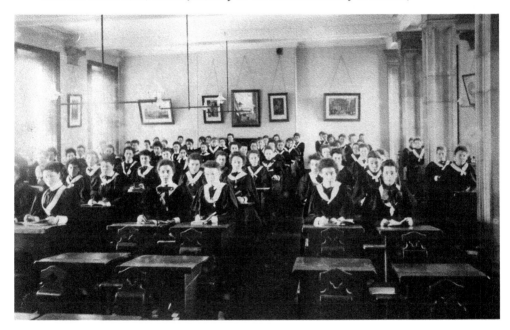

Our Lady of Mercy Training College around 1900, when it was in Lower Baggot Street. (Courtesy of the Sisters of Mercy Archives)

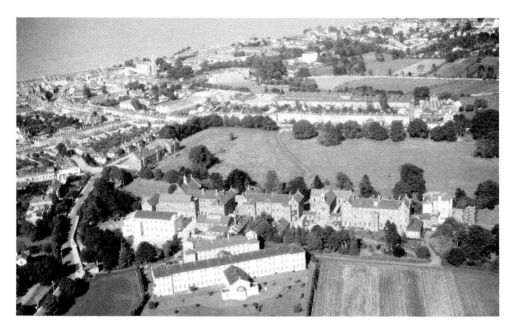

1950s aerial photo of Our Lady of Mercy Training College (commonly known as Carysfort College). (Courtesy of the National Library of Ireland)

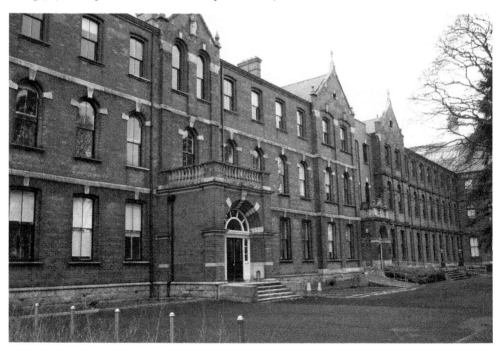

Current view of former Carysfort College. The left porch led to the 1895 Girls Industrial School, and the right porch led to the 1901/1903 Teacher Training College.

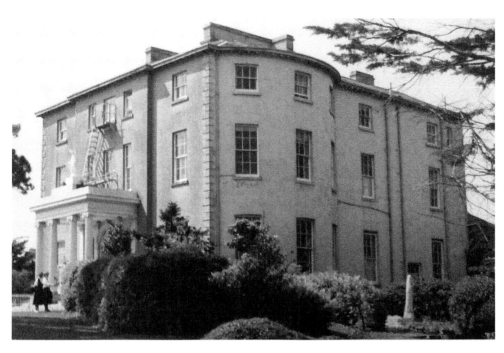

The convent of Carysfort College in former times. (Courtesy of the Sisters of Mercy Archives)

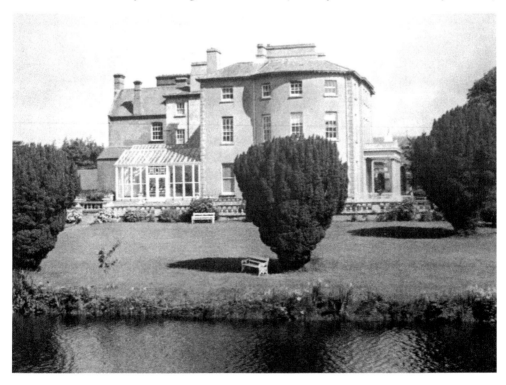

Side view of Carysfort Convent in the 1980s, as seen from the lake. (Courtesy of the Sisters of Mercy Archives)

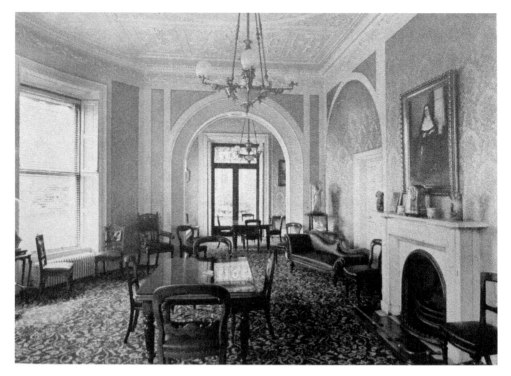

The parlour in Carysfort Convent in the nuns' time, with portrait of Sr Catherine McAuley, founder of the Mercy Nuns. (Courtesy of the Sisters of Mercy Archives)

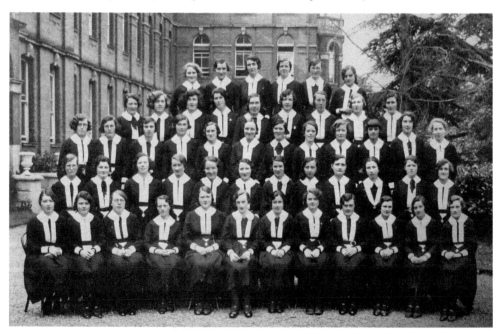

Graduates from Carysfort Teacher Training College, 1931–33. (Courtesy of the Sisters of Mercy Archives)

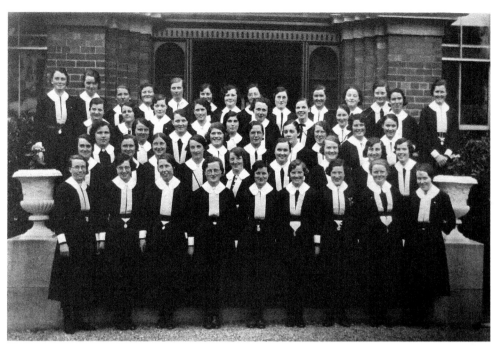

Graduates from Carysfort Teacher Training College, 1932–34. (Courtesy of the Sisters of Mercy Archives)

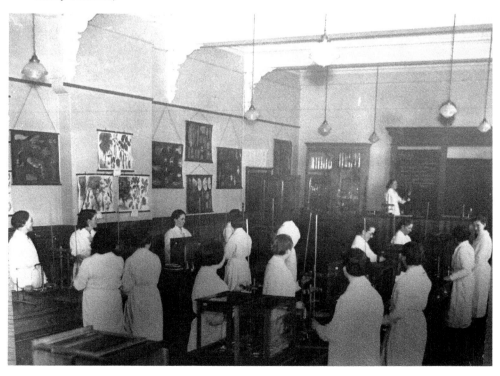

Students in Carysfort College science class, 1937. (Courtesy of the Sisters of Mercy Archives)

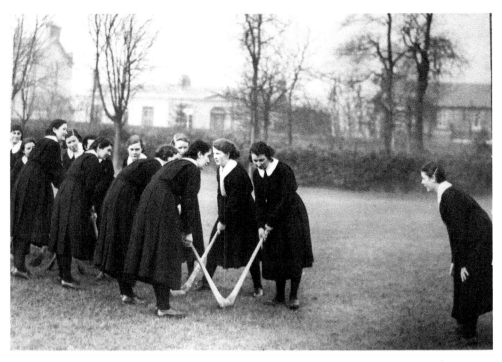

Hockey practice in Carysfort College, 1937/38. (Courtesy of the Sisters of Mercy Archives)

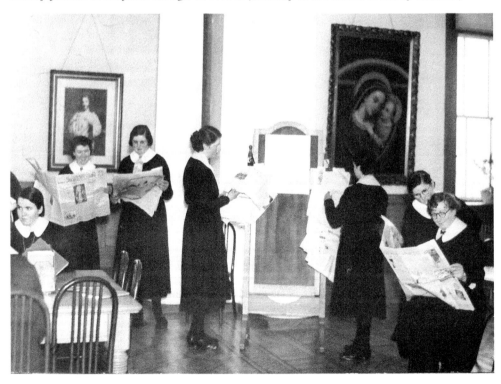

Library time in Carysfort College, 1938. (Courtesy of the Sisters of Mercy Archives)

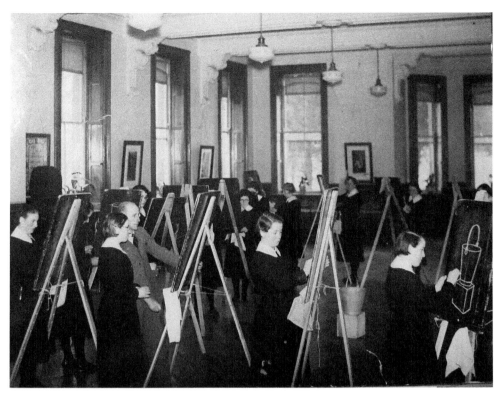

Art class in Carysfort College, 1940. (Courtesy of the Sisters of Mercy Archives)

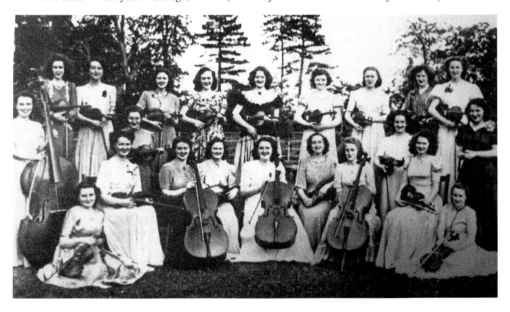

Carysfort College Orchestra, 1949. (Courtesy of the Sisters of Mercy Archives)

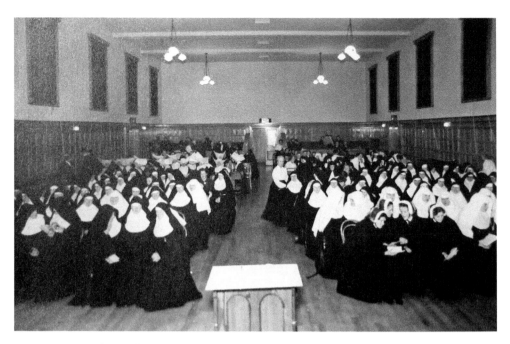

Concert in Carysfort College 1956. Note the Daughters of Charity at rear left, with their 'cornette' headdress. (Courtesy of the Sisters of Mercy Archives)

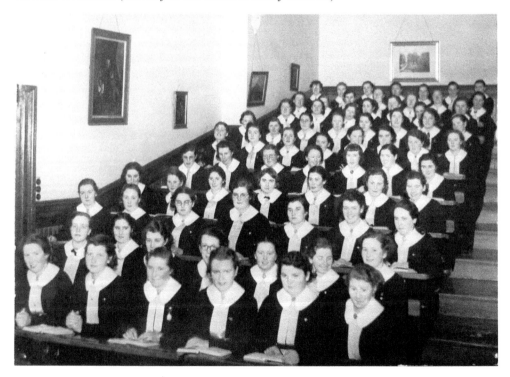

1938 lecture in 'Seomra Naomh Uinseana', Carysfort College. (Courtesy of the Sisters of Mercy Archives)

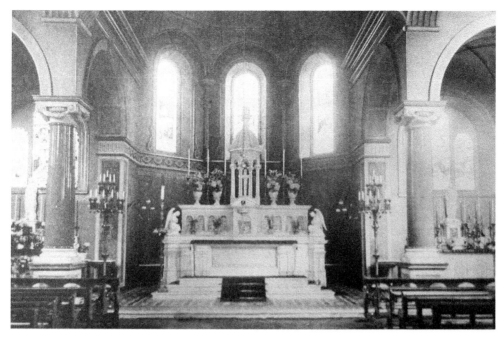

Postcard showing the Carysfort chapel, which is now the library of the UCD Smurfit College, with a mezzanine floor added. (Courtesy of the Sisters of Mercy Archives)

Meath Industrial School report, 1872. (Courtesy of the National Library)

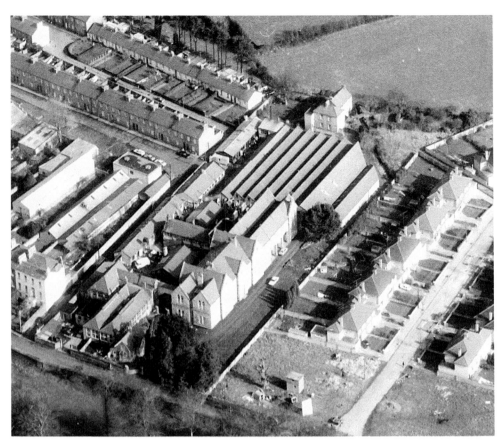

An aerial photo of the former Meath Industrial School, 1973. The T-shaped house at the rear of the site was the school infirmary, while Apex Hosiery occupied the rear factory. The former gym and lodge are visible alongside Carysfort Avenue. (Courtesy of the National Library of Ireland)

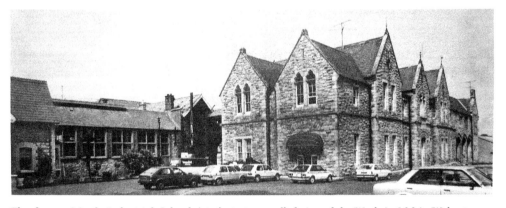

The former Meath Industrial School (at that stage called Avondale Works), 1984. Walnut Lodge is partly visible on the left, beside the former gym. (Courtesy of Osborne King & Megran)

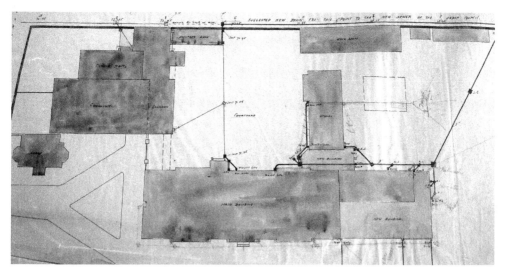

Site plan of the former Meath Industrial School around 1910, when the south-east extension was being added to the main building. (Courtesy of the National Archives)

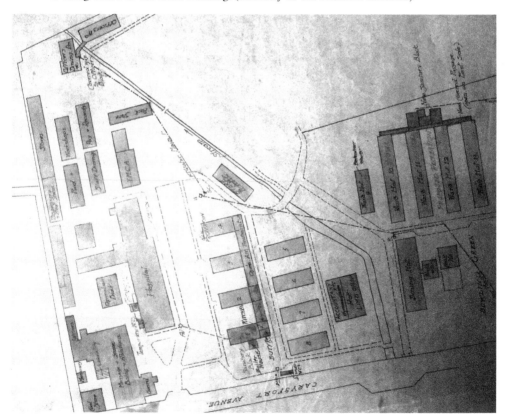

Layout of Military Orthopaedic Hospital (former Meath Industrial School), 1920. The original school buildings are clustered along the left side, and the prefab ward huts occupy the rest of the site. (Courtesy of the Office of Public Works (OPW))

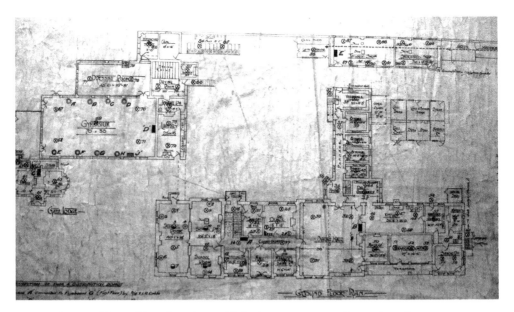

Layout of ground floor of Meath Industrial School, in preparation for rewiring for army use, 1917. (Courtesy of the OPW)

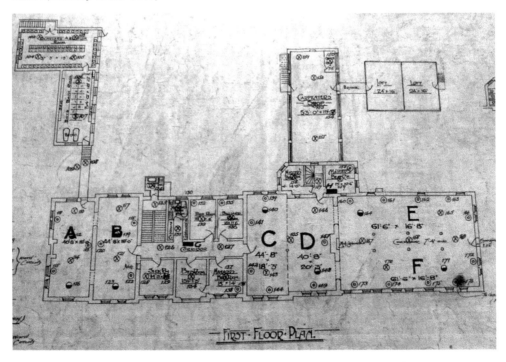

Layout of first floor of Meath Industrial School, in preparation for rewiring for army use, 1917. (Courtesy of the OPW)

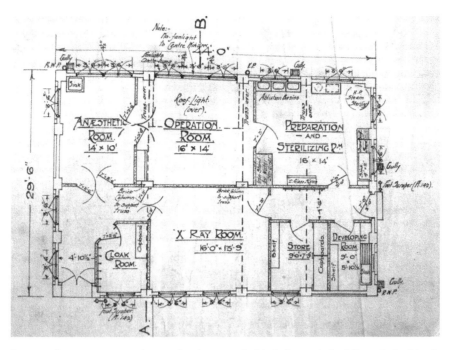

Layout of new operating theatre for the army behind the main building of the Meath Industrial School, 1918. (Courtesy of the OPW)

Dublin Crystal Glass Co. factory in the former gym of the Meath Industrial School, 1980. The gym is just visible on the right. The brick building on the left was the mortuary during army use. The two-storey building at the rear was the school laundry and bathroom block. (Courtesy of the Dublin Crystal Glass Co.)

Current view of 'Dunardagh', Temple Hill, the headquarters of the Daughters of Charity. The 1950 chapel is just visible on the left.

Cluain Muire on Newtownpark Avenue was formerly called 'Rockfield', and is located to the east of Dunardagh. The charming two-storey gate lodge dates from 1905, and is located beside the entrace to the Quaker cemetery on Temple Hill.

The Daughters of Charity operated St Theresa's as a boys' orphanage from 1925 to 1959, and then as a home for girls with mild learning difficulties.

The 1969 extension to the Daughters of Charity home (St Theresa's) for girls with mild learning difficulties.

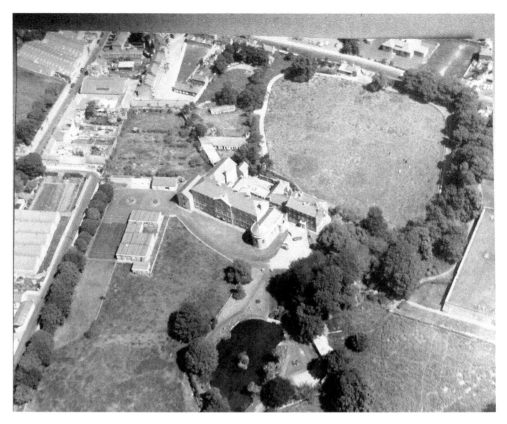

An aerial view of St Joseph's seminary on Temple Road, 1970s. Only the old house is
left, surrounded by modern houses (Barclay Court). (Courtesy of the Vincentian Archives,
St Paul's, Raheny, Dublin 5)

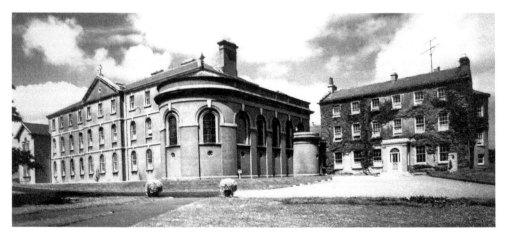

St Joseph's Seminary in the 1970s. The old house is on the right and the chapel in the centre.
(Courtesy of the Vincentian Archives, St Paul's, Raheny, Dublin 5)

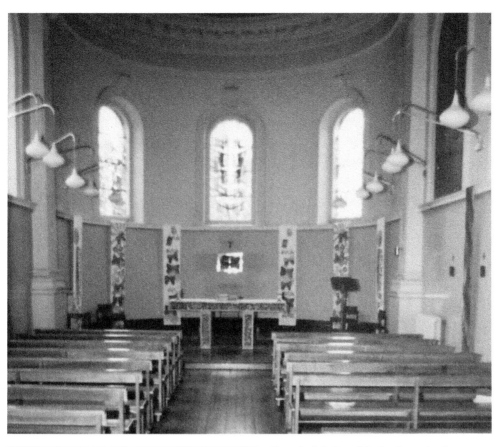

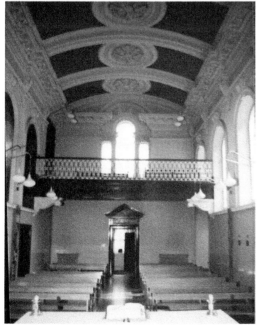

Chapel of St Joseph's Seminary in the
1970s. (Courtesy of the Vincentian
Archives, St Paul's, Raheny, Dublin 5)

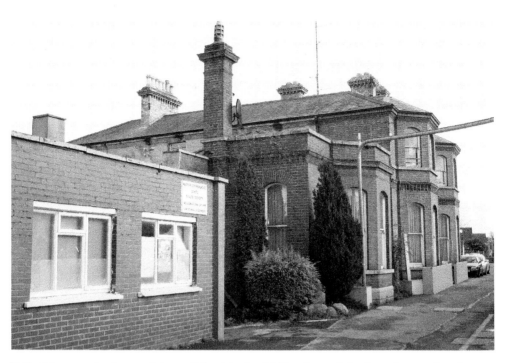

'Belfort' became the home of Avoca School in the 1930s. Avoca School amalgamated with Kingstown School in 1968, and was renamed Newpark Comprehensive in 1972.

'Melfield', beside 'Belfort', was bought by Avoca School in the 1950s and is still used by Newpark Comprehensive.

Cyril Parker was the popular headmaster who moved Avoca School in the 1930s from 'Whitehall', at 72b Carysfort Avenue, to Newtownpark Avenue. (Courtesy of Newpark Comprehensive School)

Kingstown Grammar School in 1906. From left to right, back row: G. Proud, Thompson, W.R. Keilles, H. Krall, -?-. Front row: C. McCorbie, J. Aylesbury, P. Brown, D. Rowlands, C. Krall. (Courtesy of Newpark Comprehensive School)

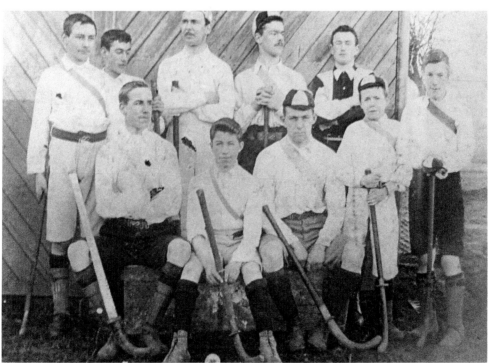

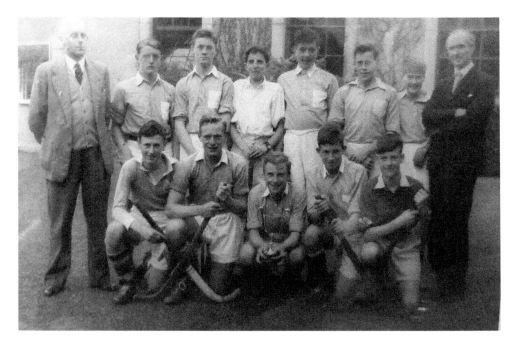

Kingstown School, winners of the Junior Hockey Cup in 1954. (Courtesy of Newpark Comprehensive School)

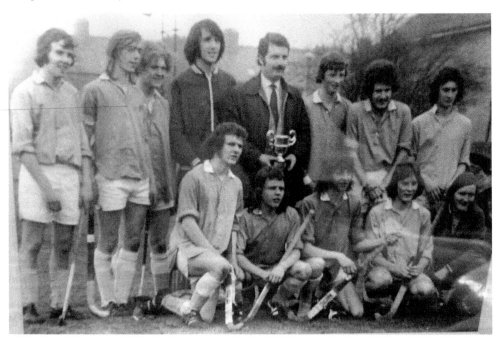

Newpark Comprehensive School, winners of Senior Hockey Cup, 1973/74. From left to right, back row: Peter Barrett, Robert Matheson, David Cole, Andrew Cox, Chris Henderson, Mark Orr, Peter Edwards, David Richardson. Front row: Jonathan Cole, Gordon Horsefield, Nickey Mitchell, Peter Chadwick, Geffory Barry. (Courtesy of Newpark Comprehensive School)

Current view of Carysfort Mixed National School, Convent Road, still owned by the Mercy nuns. The left-hand building was the 1906 Junior Preparatory College for Carysfort College. The right-hand building was the 1895 Girls' National School.

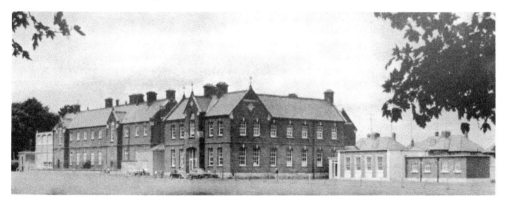

Carysfort National School (left) and Junior Preparatory College (JPC) in the centre. The single-storey oratory and infirmary on the right were part of the JPC, but now house the accounts department for the nuns. (Courtesy of the Sisters of Mercy Archives)

Current classroom in the former JPC part of Carysfort National School.

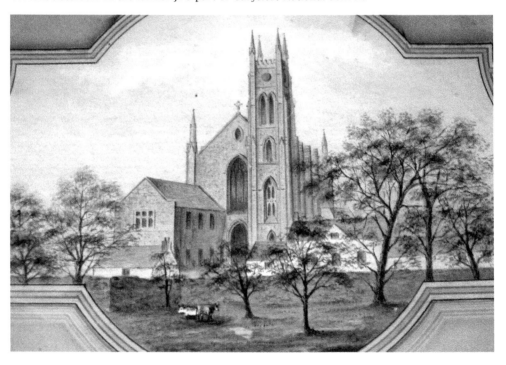

1898 painting of St John the Baptist church on Temple Road, with the two-storey Boys' National School in the front. (Courtesy of the Senior College Dún Laoghaire)

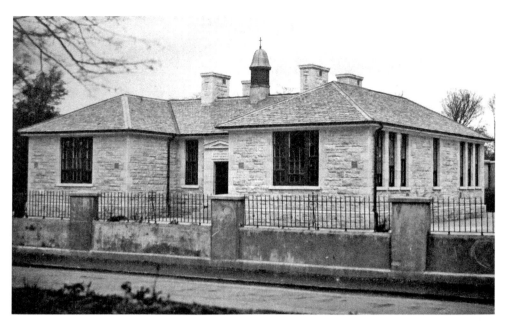

The new St John the Baptist Boys' National School was built in 1926, to the south of the church, and closed in 1980, when the boys transferred to Carysfort Girls' National School on Convent Road. (Courtesy of the National Library of Ireland)

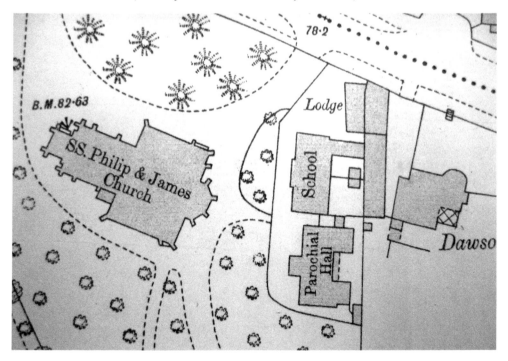

Booterstown National School was beside St Philip & St James' Anglican church on Cross Avenue. The Barrett Cheshire Nursing Home now occupies the site of the lodge, school and parochial hall. (1910 Ordnance Survey map extract courtesy of the Valuation Office)

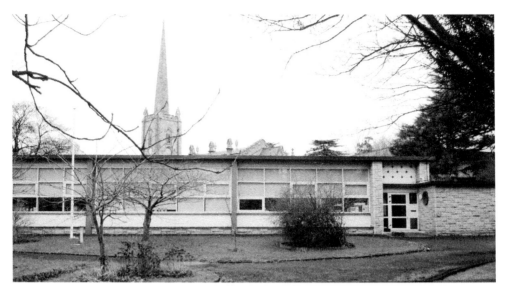

The new Booterstown Mixed National School opened in 1957. The graceful spire of St Philip & St James' church is in the background.

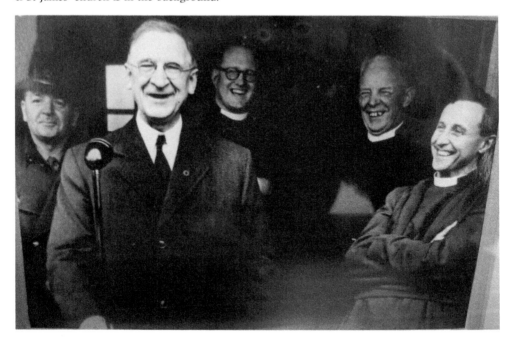

22 March 1957: Lt Col. Sean Brennan (aide-de-camp), Eamon de Valera (Taoiseach), Revd R.H. Bertram, Canon E.M. Bateman, and a totally relaxed Most Revd George Otto Simms (Anglican Archbishop of Dublin), at the opening of the rebuilt Booterstown National School beside St Philip & St James' Anglican church. (Courtesy of the Booterstown National School)

The lovely mosaic floor tiles in the lobby of the Carnegie Library, as seen in 2006. The 1889 date on the cross appears to be a mistake, since the UDC was not set up until 1898, and the library was not built until 1905.

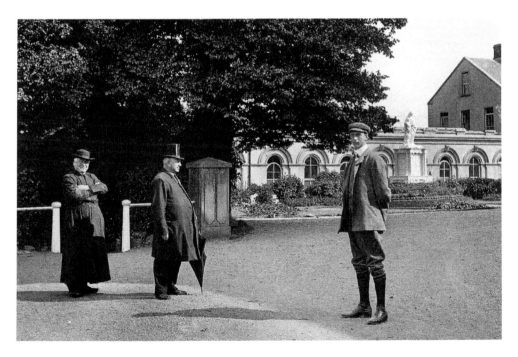

A youthful Eamon de Valera in 1904 in Blackrock College, with Brother Columncille Heffernan and Father Jules Botrel (top hat and umbrella). Note Immaculate Heart House on the right (now gone). (Courtesy of Blackrock College)

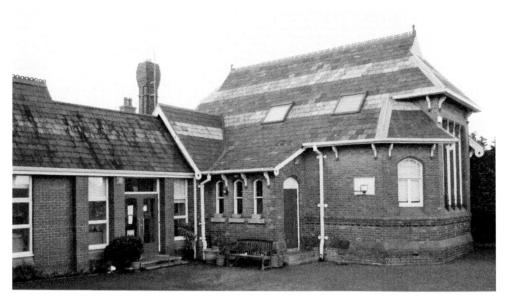

Current view of All Saints' Mixed National School at top of Carysfort Avenue. The adjoining Blackrock Veterinary Clinic (behind the tall building) was once the home of the schoolmistress. In the early twentieth century, some boys from the nearby Meath Industrial School were pupils here.

Presentation of certificates to Adult Education Foundation Course, Blackrock Technical School, 1982. From left to right, back row: J. Griffin, G. Geraghty, P. O'Donnell, S. Clayton, G. Cox, T. Dunning, T. Visser, F. Green. Front row: Sr B. Hunter, M. Lennon, E. McGoldrick, A. De Valera, H. McArdle, M. Dowling. (Courtesy of the Senior College Dún Laoghaire)

3

RELIGION

ST JOHN THE BAPTIST, TEMPLE ROAD

Lewis, writing in 1837 (using the 1831 Census) records a chapel in the village, built in 1822 at a cost of £750. He was referring to the public chapel adjoining the Carmelite Convent, abutting Sweetmans Avenue. The nuns had a smaller private chapel to the west of their convent.

In 1787, Booterstown, Blackrock, Stillorgan and Dundrum were made into one parish, following separation from the vast Donnybrook parish. In 1879, Dundrum and Stillorgan became a separate parish. In 1922, both Booterstown and Blackrock became independent parishes.

St John the Baptist church, designed by Patrick Byrne, was dedicated in 1845, following the laying of the foundation stone in 1842 by Fr Theobald Mathew. The east aisle was added in the 1850s, and the poorly designed west aisle in the 1930s (called St Anne's chapel). The presbytery dates from 1856.

The church contains some nice stained-glass windows, including the three-light window in St Anne's chapel, created in 1955 by Evie Hone.

Guardian Angels chapel of ease opened in Newtownpark Avenue in 1967.

CHRIST CHURCH, CARYSFORT AVENUE

This was opened as the Episcopal Chapel at the beginning of the nineteenth century, by dissenter Revd Thomas Kelly – his followers were called 'Kellyites'. Kelly was originally Church of Ireland, and then he became a Methodist. The sect did not last long, and was taken over by the Church of Ireland. A large nave was added to the small church in 1839.

The church closed in 1960 (despite a High Court attempt by some parishioners to prevent this), and the building was demolished in 1966. The site is now the public car park to the south of Zurich office block. Their Celtic cross First World War memorial is now in the Peace Garden on the west side of St Philip & St James' church in Cross Avenue, and their framed First World War Roll of Honour is in the north-east porch of that church.

ALL SAINTS, CARYSFORT AVENUE

This very attractive Anglican church dates from 1870, and was designed by John McCurdy, using a north-south orientation (by convention, the altar should be at the east end). The interior is enhanced with lovely stained-glass windows, by such artists as Wilhelmina Geddes of An Túr Gloine, Earley & Co. of Camden Street, Heaton Butler & Bayne of London, and James Powell & Son of London, all inserted at different dates. Of particular interest is the 1930s and 1940s paintings by Rosaleen Brigid Ganley (RHA) in the baptistery, with faces of her own family. Note the old rood arch in timber over the entrance to the sanctuary.

The vicarage behind the church was built a few years after the church, and is now in private ownership.

ST PHILIP & ST JAMES, CROSS AVENUE

The parish was founded in 1821, and the church opened in 1824. The Pembroke family provided the site, and James Digges La Touche paid most of the building costs. In 1868, the south transept and chancel were added, and the north transept was built in 1876. Noteworthy interior features include the vaulted and ribbed ceiling, some Heiton Butler & Bayne stained-glass windows, Forster & Andrews 1876 organ in the chancel, and the 1921 First World War memorial comprising the half-height marble reredos behind the altar, designed by Sir Thomas Deane, and made by C.W. Harrison of Pearse Street.

The former rectory on the south side of Mount Merrion Avenue is now the Iranian Embassy, and dates from the end of the nineteenth century.

ST ANDREW'S, MOUNT MERRION AVENUE

Albion House was demolished in 1899 to make way for this unusual and attractive Presbyterian church. Murray & Forrester of London designed an octagonal structure, with granite as the main material and Portland stone dressings around windows, etc. The huge organ, which was part funded in 1912 by Scottish philanthropist Andrew Carnegie, was originally on the altar, but moved to the rear in 1949.

Externally, note the burning bush (from the Book of Exodus in the Old Testament) in bas-relief over the entrance, with the Presbyterian motto 'Ardens sed Virens', which is Latin for 'burning but flourishing'.

METHODIST CHURCH, NEWTOWN AVENUE

The Methodists built a small plain church in 1847 between the present 72 and 74 Georges Avenue. Street directories for 1850 also record Methodists in Sydney Place. After the Methodists moved to a new, larger church in Newtown Avenue in 1861, the Georges Avenue premises may have been used as a church hall, until taken over by the Plymouth Brethren at least in the 1890s. The Brethren stayed until the 1960s, after which the property was used for other purposes, and is currently occupied by a group of architects. The 1901 Census lists the building as a Brethren Meeting House, and the 1911 Census lists it as a Gospel Hall.

The Methodists built a much larger church in 1861 in Newtown Avenue, comprising a girls' secondary school on the ground floor and the church on the first floor, accessed by two flights of timber stairs in the porch. The organ chamber was subsequently added behind the altar. The congregation moved to Dún Laoghaire in 1998, and the Blackrock building is now called 'Urban Junction', a Methodist-sponsored Christian community of young people, who meet every week in the former school and use guitars to accompany their hymns.

The original first-floor church is now a children's crèche, and the organ has been removed. On Tuesday evenings, the space becomes a rehearsal area for the Stedfast Band. This lively brass band was founded in Dún Laoghaire in 1951 by Stan and George Dyke, with past members of The Boys Brigade, and has been associated with Blackrock Methodist church for the past thirty-five years. They perform regularly at public events and in competitions, and anyone, male or female, is welcome to join.

PLYMOUTH BRETHREN

A group of Plymouth Brethren, a Christian community, used the former Methodist Church at 72a Georges Avenue from at least the 1890s to the 1960s.

There was another group in 22 Sydney Avenue (Sydney Hall) from around 1879 until 1953, when they moved to South Hill Park on the Stillorgan Road, which today is called South Hill Evangelical Church. Brethren gather in Meeting Halls (not to be confused with Quaker Meeting Houses).

QUAKER CEMETERY, TEMPLE HILL

The Religious Society of Friends, a Christian community, opened this charming wooded cemetery in 1860. In the old days this area was called Newtown Castle Byrne. In the 7-acre site, all the small limestone headstones are identical, even though many names are of important business families, such as Grubb, Allen, Goodbody, Fairbrother, Pim, Todhunter, Waring, etc, signifying that all humans are equal in the eyes of God.

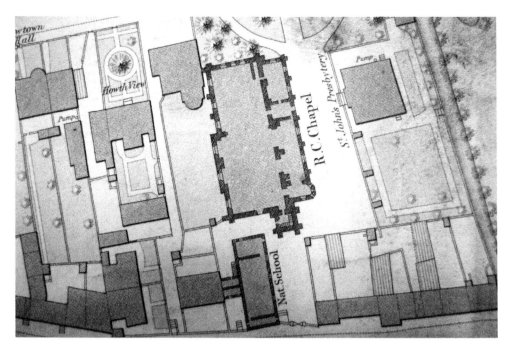

Plan of St John the Baptist church and National School in the 1870s. (Ordnance Survey map extract courtesy of the Valuation Office)

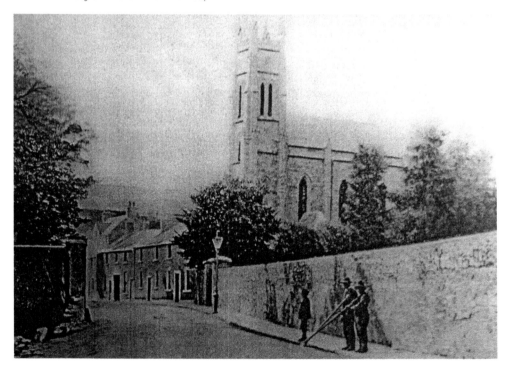

St John the Baptist church, *c.* 1900. Temple Road in bygone days was called Back Road. (Courtesy of the National Library of Ireland)

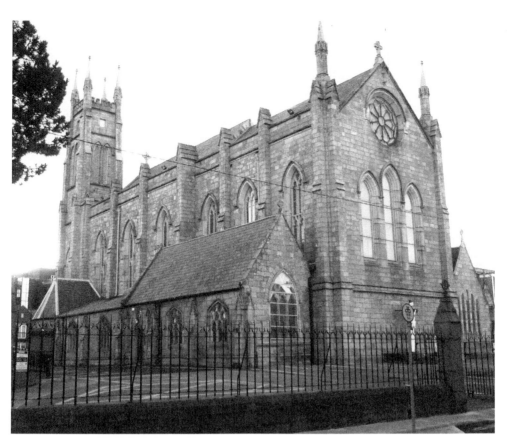

Current view of St John the Baptist church.

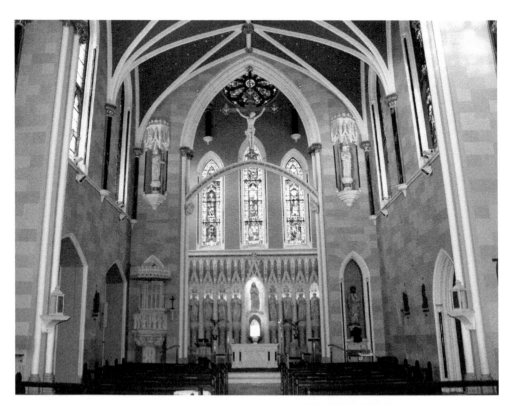

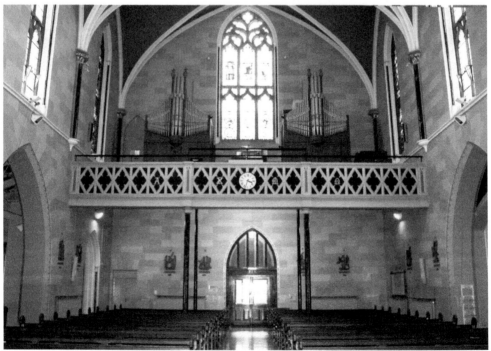

Current interior of St John the Baptist church.

MASS:

Sundays and holidays of obligation—7, 8, 9, 10, 10.45, 11.30 a.m.; 12.
Week-days—7.15, 8, 10 a.m.
Children's Mass—9 a.m. on the 3rd Saturday of the month.

CONFESSIONS:

Every week-day at 10.30 a.m.
Every Saturday 10.30 a.m. to 1 p.m.; 2.30 to 3.30 p.m.; 7 to 9 p.m.
Eves of holidays of obligation and of First Fridays—10.30 a.m. to
1 p.m.; 7 to 9 p.m.
Children's Confessions—10.30 a.m. on 3rd Friday of the month.

BAPTISMS:

12 o'clock each Wednesday or by arrangement.

SODALITIES AND ASSOCIATIONS:

Sodality of the Sacred Heart for Men:
Meeting: Second Friday of the month at 8 p.m. Mass and General
Communion on the second Sunday of the month at 9 a.m.
Sodality of the Sacred Heart for Women:
Meeting: Fourth Friday of the month at 8 p.m. Mass and General
Communion on the fourth Sunday of the month at 8 a.m.
Children of Mary Sodality:
Meeting: 3 p.m. on the second Sunday of the month at the Convent
of Mercy, Craysfort, Mass and General Communion on the third
Sunday of the month. 8 a.m.
Legion of Mary—Meeting: 8.30 p.m. each Monday.
Patrician Club—Meeting: 8 p.m. each Wednesday.
Purgatorian Society—Devotions in church each Monday, 8.30 p.m.
Society of St Vincent de Paul—8.30 p.m. every Tuesday.
Boy Scouts—Meeting every Saturday, 3-5 p.m. (Cubs).
 Meeting every Wednesday, 7.30-9.30 p.m. (Scouts).
Total Abstinence Association—Applications for membership received
at 8-9.30 p.m. each Monday for men; each Thursday for women.
Meetings every three months: notice given beforehand.

DEVOTIONS:

Every Sunday at 5 p.m.; Rosary, Sermon, Benediction.
Benediction—Every Friday at 8 p.m.; Rosary and Benediction.
Holy Hour—First Sunday of the month; 4.30 p.m.
Perpetual Novena in honour of Our Lady of the Miraculous Medal—
Each Monday at 8 p.m.

Extensive programme of activities in St John the Baptist church in the 1960s.

Christ Church Anglican church in Carysfort Avenue, c. 1900. It was demolished in 1966, and the site is now the public car park beside Zurich Insurance. (Courtesy of the National Library of Ireland)

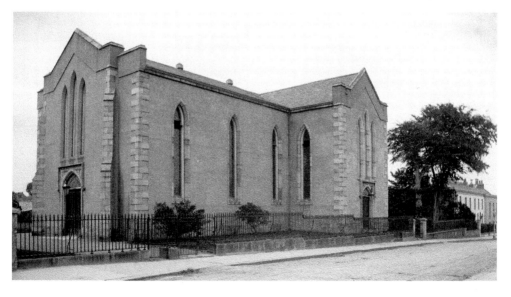

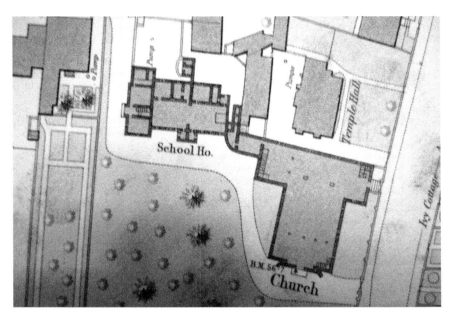

Plan of Christ Church Anglican church, Carysfort Avenue, with the National School to rear. The large nave of the church was an 1839 extension (Ordnance Survey extract courtesy of the Valuation Office)

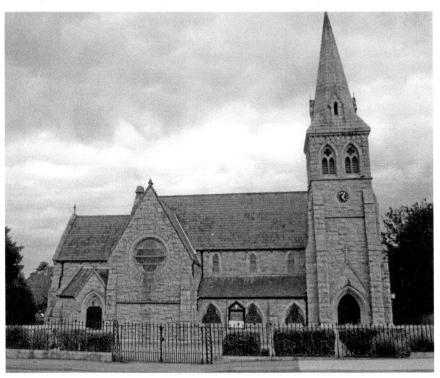

All Saints' church on Carysfort Avenue opened in 1870, and has the distinction of never having been extended.

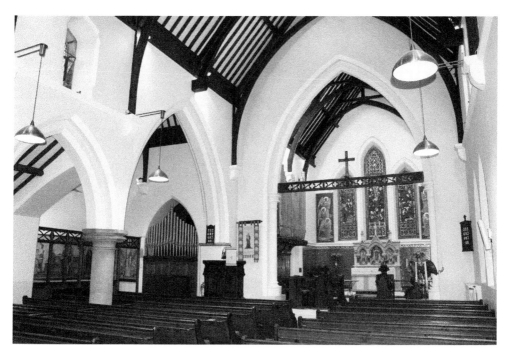

The interior of All Saints' church is very attractive. Note the old rood arch (beam) over the entrance to the sanctuary, the built-in organ on the west side of the altar, and the baptistery screen on the left.

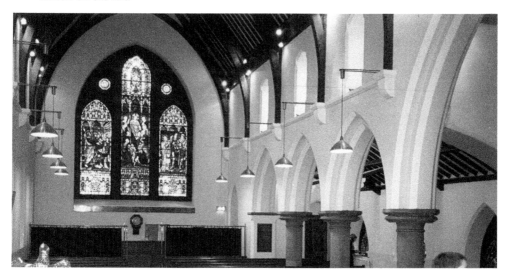

Interior of All Saints' church, looking towards the rear stained-glass window, erected in 1898 by Heaton Butler & Bayne of London. There is one side aisle, with low-level trefoil windows.

The baptistery screen in All Saints' church, painted by Rosaleen Brigid Ganley in the 1930s and 1940s, with faces copied from her own family.

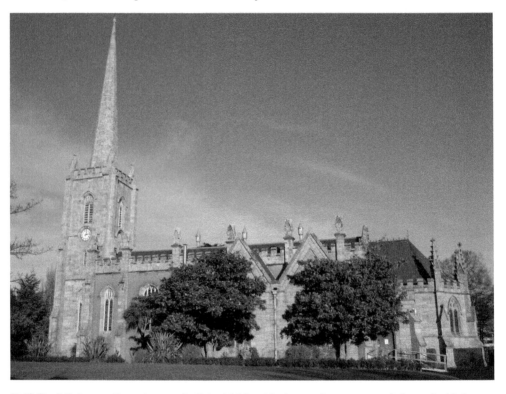

St Philip & St James, Cross Avenue, built in 1824, with the south transept and chancel added in 1868, and north transept added in 1876. The graceful slender spire is a noted landmark.

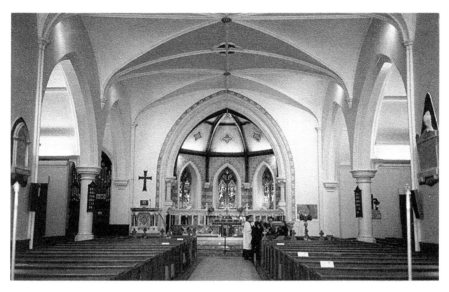

The interior of St Philip & St James is very homely, partly because there is a vaulted ceiling to hide the roof structure.

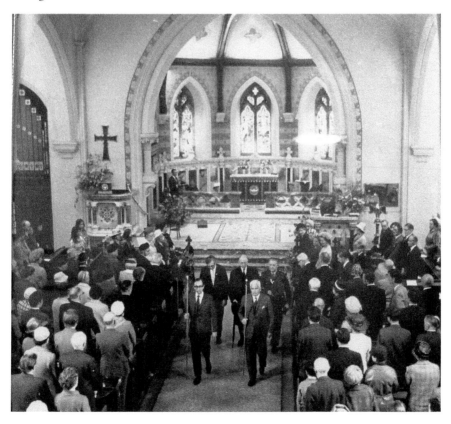

This 1971 photo shows Eamon de Valera at the 150th anniversary of the founding of St Philip & St James' parish. (Courtesy of St Philip & St James)

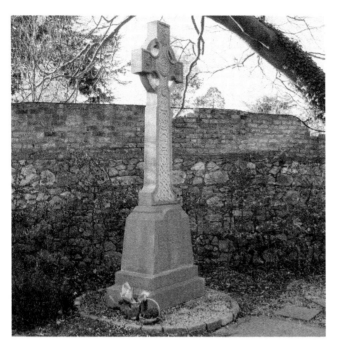

This First World War Memorial Cross beside the church of
St Philip & St James was originally positioned beside Christ
Church, Carysfort Avenue.

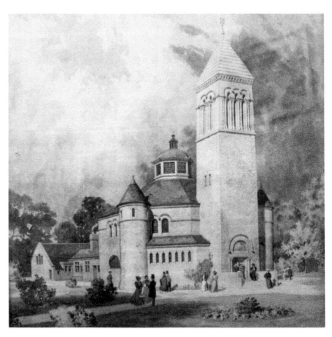

This delightful watercolour shows the architect's 1899 proposal
for St Andrew's Presbyterian church on Mount Merrion Avenue.
(Courtesy of St Andrew's)

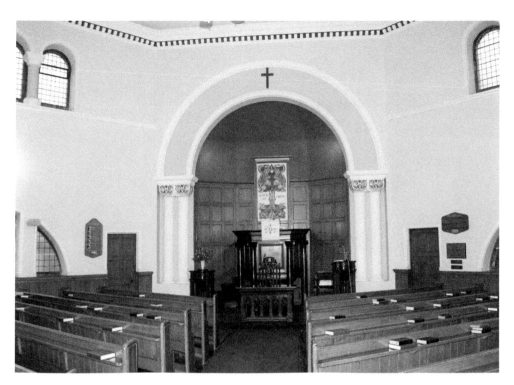

Interior of St Andrew's, facing the pulpit and communion table.

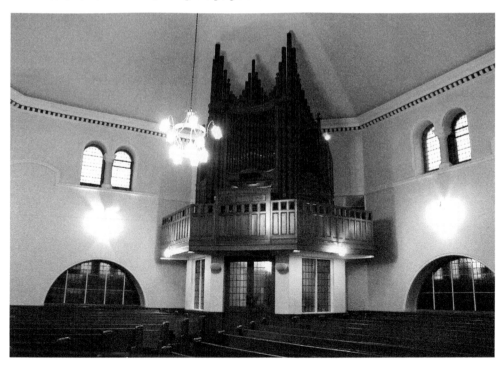

The organ in St Andrew's was repositioned over the entrance lobby in 1949.

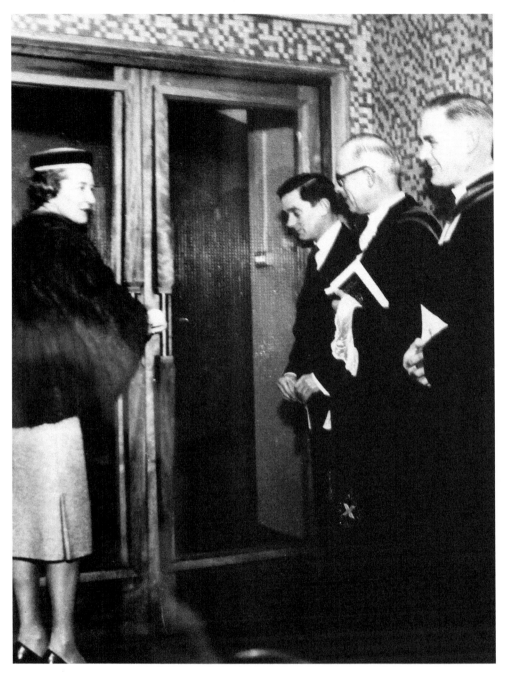

The official opening of St Andrew's parish hall on 6 December 1959. From left to right: Mrs Scott McLeod, Mr Baird (architect), Revd Desmond Black, Dr T.A.B. Smyth. (Courtesy of St Andrew's)

The 1861 Methodist church on Newtown Avenue is now called Urban Junction, with a crèche in the first-floor former church on weekdays, and 'Ignite' Christian services in the former ground-floor school on Sundays. The former Blackrock fire station in the centre was substantially demolished in 2013 (leaving just the front wall/arch) to make way for the new Blackrock Further Education Institute.

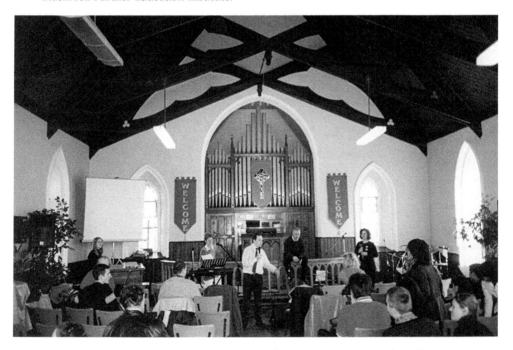

The Methodist church in Newtown Avenue, during an 'Ignite' Sunday Christian service. The organ is now gone, and the entire area used as a crèche on a weekday, including the practice venue for the Stedfast Brass Band.

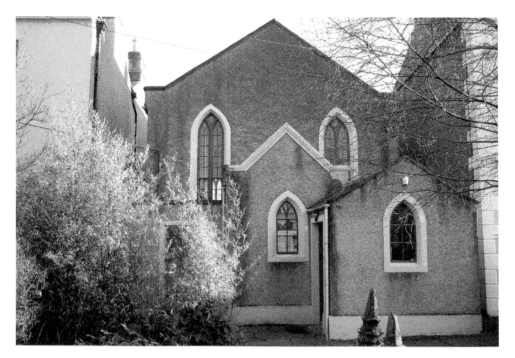

This former Methodist chapel between 72 and 74 Georges Avenue dates from 1847, but has been used by the Plymouth Brethren for most of the twentieth century. It is now occupied by a group of architects.

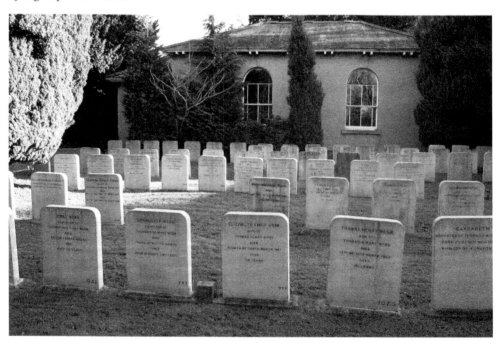

The Religious Society of Friends (commonly called Quakers) opened their cemetery in Temple Hill in 1860. All the limestone headstones are identical.

4

HEALTH

BLACKROCK CLINIC, ROCK ROAD

Joseph Sheehan, James Sheehan, Maurice Neligan and George Duffy were the founders of this private clinic, which houses a variety of medical consultants who formerly had rooms in the Georgian houses around Fitzwilliam Square. The promoters demolished Rosefield House (formerly called 'Belleville' in the eighteenth century), and opened the clinic in 1984. The octagonal building (with echoes of St Andrew's Presbyterian church on nearby Mount Merrion Avenue) was designed by Campbell Conroy Hickey, and features a full-height atrium as the core of the building, on top of which is the symbol of medicine, two serpents entwined around a staff, representing the Hippocratic Oath, sworn by members of the medical profession. The adjacent hospital opened in 1986 and has a plain design.

The Sion Hill nuns' cemetery is to the east of the new multi-storey car park. Each grave is marked by a simple concrete cross, and Catherine and Maebh O'Nolain are buried here (sisters of Myles na gCopaleen or Brian O'Nolain).

BLACKROCK HOSPICE, SWEETMANS AVENUE

The Carmelite nuns (an enclosed order, who were never seen in public) settled in Sweetmans Avenue in 1823 and supported themselves by baking 'altar breads' for the local churches. They operated a mixed national school from one of the outbuildings, until other schools were established in the area. There was a public chapel fronting on to Sweetmans Avenue, until St John the Baptist was opened at Temple Road in 1845, and the former was probably supervised by the nuns. The nuns had a small private chapel for their own use, but replaced it in 1900 with the present charming building.

The field on the other side of Sweetmans Avenue was nicknamed 'Australia', because it was so difficult for the contemplative nuns to reach. There was a shed or building near here, where a young Bob Geldof (of The Boomtown Rats fame) practised his rock music, much to the annoyance of the nuns.

In 1997, the nuns (Margaret Mary Quigley, Maev O'Higgins, and Ann Delaney) sold their convent and site of 2.63 acres for £1.675 million to the Luke Smyth Foundation. In 2003, the Sisters of Charity from the Hospice in Harold's Cross

opened a small satellite hospice, with twelve en-suite bedrooms and a day-care centre, comprising the original convent building, a new extension, and the 1900 chapel. The front of the site abutting Frescati Road was developed as apartments. The Health Services Executive now funds the running of the two hospices.

The last five nuns dispersed to other convents, but the order still owns the tiny walled cemetery, where fifty-three nuns are buried.

The 1901 Census records fourteen Carmelite nuns in Blackrock. There were thirteen nuns in the 1911 Census.

ST PATRICK'S INFANT HOSPITAL, TEMPLE CRESCENT

St Patrick's Infant Hospital and Nursery Nurses College was founded by Miss Mary Cruice in 1910 as St Patrick's Guild. In 1929, Blackrock Urban District Council leased Neptune House (a 1760s house on 2.5 acres, also called Temple Hill, and once occupied by the Earl of Clonmel) to the guild, and they moved from 39 Mountjoy Square. In 1943, the guild was taken over by the Irish Sisters of Charity. The nuns were also engaged in the care and adoption of illegitimate children, the latter from the guild's office in 50 Middle Abbey Street (Haddington Road in the 1980s), and one of their many newspaper ads in the 1950s read as follows: 'Good Catholic home wanted for little Liam, aged eight months. Lovable little boy, fair complexion, blue eyes, healthy. No fee; full surrender. Home must be well recommended. Priest's reference essential. For particulars, apply to: The Sister-in-Charge, St Patrick's Guild, 50 Middle Abbey Street, Dublin.'

In 1987, because of government cutbacks, the hospital closed and the nuns (Mary Berkery, Rosaleen Murphy and May McCraven) sold the property to Temple Hill Ltd for £426,000. From the early 1990s, the property was occupied by Trinity College, but has been empty for the last few years, and was sold in 2013.

During the First World War, the property was lent by Herbert Power, of Faithlegg, County Waterford and used as Temple Hill Auxiliary Hospital, treating British soldiers shipped over from Europe. The hospital was manned by the Blackrock Nursing Division of St John's Ambulance Brigade, sometimes assisted by Red Cross Voluntary Aid Detachments (VAD). There were thirty-six beds, and around 500 patients were treated in the four-year period. The first matron was Mrs Middleton Curtis. Nearby Monkstown House was another voluntary auxiliary hospital, but reserved for wounded officers only.

CLUAIN MHUIRE, NEWTOWNPARK AVENUE

'Rockfield', a 1760s house, was a partial auxiliary hospital during the First World War. The Geoghegan family converted some rooms to accommodate eight wounded soldiers, and employed a nurse to mind them. About 200 soldiers spent time here. After the war, it was a nurses' home associated with the Military Orthopaedic Hospital on Carysfort Avenue (the former Meath Industrial School). In the 1950s, the Sisters of Mercy used the building as a female psychiatric unit before, in the 1970s, St John of God Brothers took over the psychiatric unit, and renamed it Cluain Mhuire.

BLACKROCK ORTHOPAEDIC HOSPITAL, CARYSFORT AVENUE

(See Meath Industrial School in Chapter 2.)

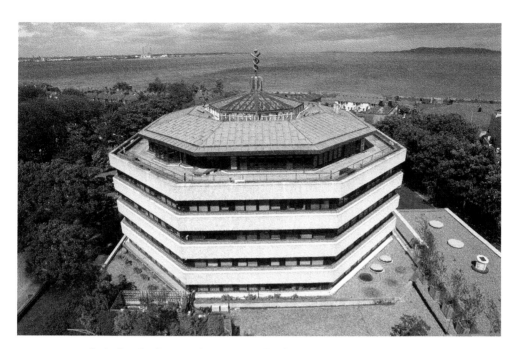

A view of Blackrock Clinic, with Howth in the distance on the right, and the iconic Pigeon House twin-chimneys on the left. (Courtesy of the Blackrock Clinic)

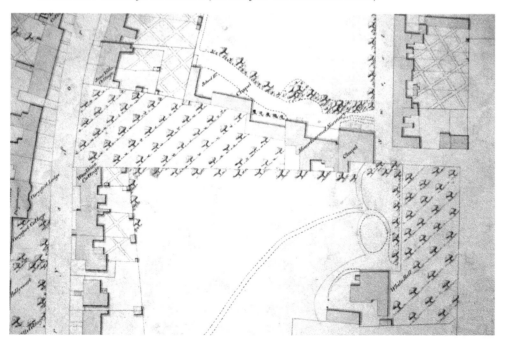

1837 Ordnance Survey extract, showing the Carmelite Convent. Blackrock's only Catholic chapel abuts Sweetmans Avenue, beside Mount Carmel Nunnery, and the nuns' private chapel, and finally the small school for the poor. 'Whitehall' is at lower right, later to be used as Avoca School. (Courtesy of Trinity College Dublin)

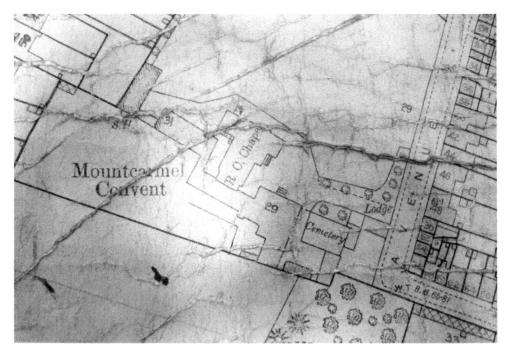

1907 Ordnance Survey extract showing the Carmelite Convent. The new 1900 chapel has been built, and a cemetery formed on the site of the public chapel (both still in existence today). (Courtesy of the Valuation Office)

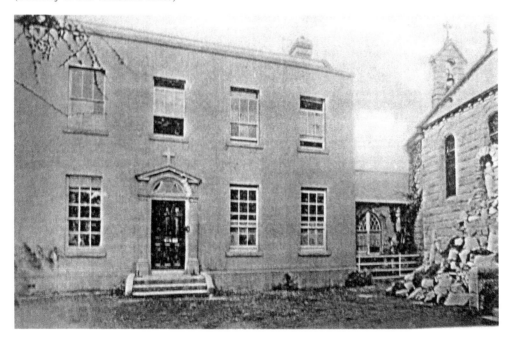

Carmelite convent, Sweetmans Avenue. (Courtesy of the Carmelite nuns)

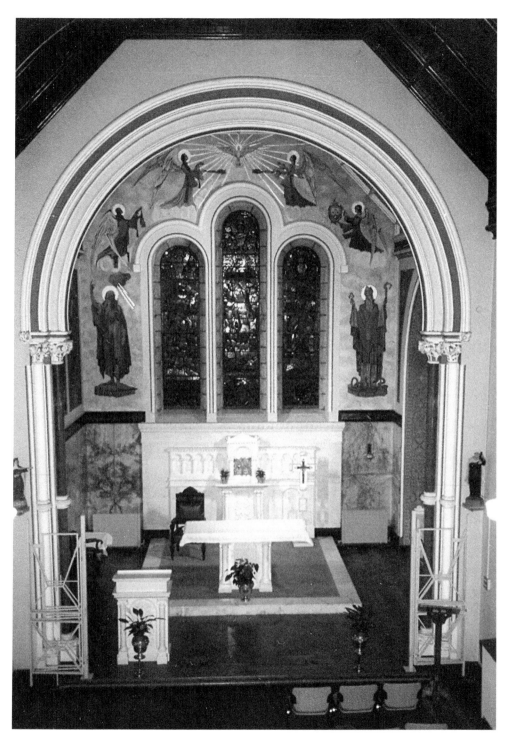

The lovely Carmelite chapel is still in use.

Beside the entrance to the Carmelite chapel in 1985. From left to right: Sr Martha, Sr Gloria, Sr John, Sr Brigid, Sr Teresa Margaret. (Courtesy of the Carmelite nuns)

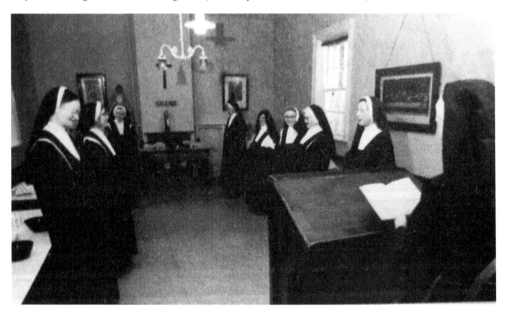

Carmelite refectory (dining room), 1985. Sr John is on the left and Sr Teresa on right. (Courtesy of the Carmelite nuns)

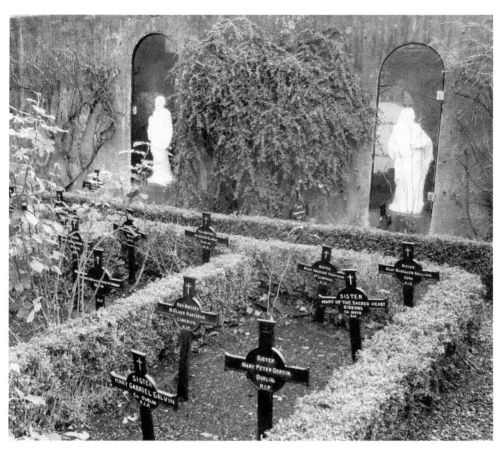

The Carmelite nuns' walled cemetery in Blackrock is still in use today.

1980s view of the Nurses' Home attached to St Patrick's Infant Hospital. (Courtesy of the Irish Architectural Archive)

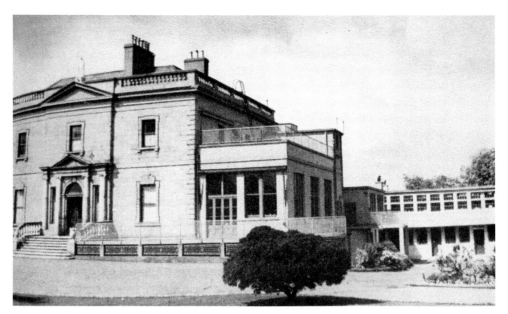

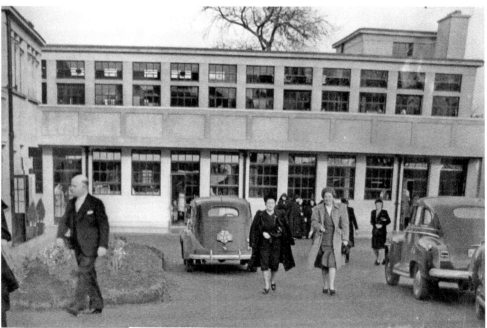

St Patrick's Infant Hospital, Temple Crescent, in the 1960s. (Courtesy of the Irish Sisters of Charity)

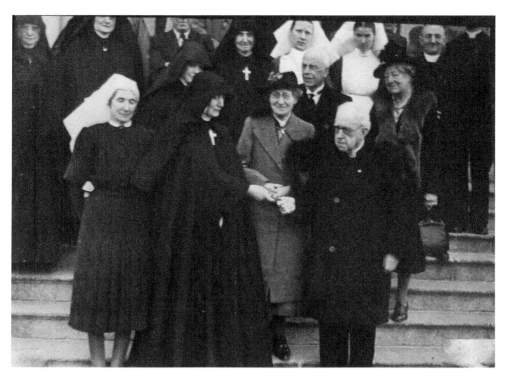

Sr Mary Camillus O'Donoghue receiving the keys of St Patrick's Infant Hospital from Fr Connell, parish priest of Blackrock, 8 May 1943. The lady in the centre is Ms Mary Cruice, the former owner and administrator. (Courtesy of the Irish Sisters of Charity)

During the First World War, Temple Hill Auxiliary Hospital was staffed by a British Red Cross Voluntary Aid Detachment (VAD). Later the building became St Patrick's Infant Hospital. (Courtesy of the Military Archives, Cathal Brugha Barracks)

Temple Hill Auxiliary Hospital was also staffed by a St John Ambulance Brigade Voluntary Aid Detachment (VAD). (Courtesy of the Military Archives, Cathal Brugha Barracks)

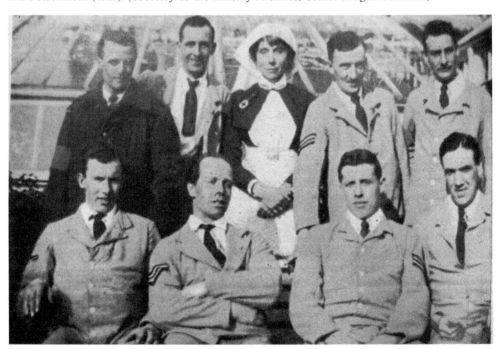

During the First World War, Rockfield House on Newtownpark Avenue was partly used as an Auxiliary Hospital. This building is now Cluain Mhuire. (Courtesy of the Military Archives, Cathal Brugha Barracks)

5

RECREATION

BLACKROCK BATHS, BESIDE DART STATION

The Dublin Swimming Club was founded in 1880, meeting at Seapoint Baths, then in Blackrock House (which had a small harbour), and finally settling in the open-air Blackrock Baths when it was built in 1887. They became affiliated to the Irish Amateur Swimming Association, which was set up in 1893. Other clubs based in the Blackrock Baths included Dublin University (now called Trinity College), UCD, Leinster Ladies, Pembroke/Merrion, and Blackrock College.

The 1887 baths were built of concrete by Ingram Dixon, to a design by Kaye Parry, with a men's section, 165 feet by 100 feet (3 feet to 7½ feet deep), and women's section, 102 feet by 54 feet (few inches to 7ft deep). The baths were rebuilt in 1928, in preparation for the Second Irish Tailteann Swimming Games (a sort of Olympics). British Pathé News filmed the Tailteann Games, and other swimming galas. There was previously a men's bathing spot in this location, and a ladies' bathing spot a little to the south, provided by the railway company. Blackrock Baths closed in the 1980s, and is now mostly filled in with sand.

There were also hot and cold baths to the south of Seapoint Station, at present-day 17 and 17a Brighton Vale.

BLACKROCK PARK, ROCK ROAD

In the middle of the nineteenth century, the sea went in under the new railway, via culverts, flooding the present park, and men's and women's bathing areas were laid out.

In the 1870s, the new Blackrock township made the area into a 35-acre public park, complete with ornamental lake, bandstand, etc. In the second half of the twentieth century, the concrete island at the north end of the lake was designed by Michael Mac Liammoir for open-air plays.

BLACKROCK BOWLING AND TENNIS CLUB LTD, GREEN ROAD

The Blackrock Tennis Club is listed in *Thom's Directory* in Carysfort Avenue in 1895, with John Lanphier (manager of Ulster Bank) as secretary.

The Blackrock Bowling and Lawn Tennis Club Ltd was incorporated in 1906, with Thomas Hayes as chairman and Arthur Kelly as honorary secretary. A plot of land of 1½ acres was acquired on the north side of the present Green Road, and was ready for both sports the following year. The present facilities include a grass bowling green, four all-weather tennis courts, and a central 1985 pavilion.

Many people will have fond memories of the weekly dances and 'hops' which featured in the 1940s, '50s and '60s, and were open to non-members for miles around.

BLACKROCK ATHLETIC CLUB

During the Second World War, Ireland was neutral, but kept the army on alert during 'The Emergency', and also organised a Local Defence Force (LDF) of civilians. The LDF in the Blackrock region was active in athletics, and so in 1944 started a club in Booterstown National School. The first committee comprised Leo Fagan (who owned the Punch Bowl pub), W.J. Quinlan, Joe Hayden, Tommy Kelly, Jimmy Mahony, Eddie Kelly, Jimmy Reddin, Peadar Murphy, and Jack Burke.

The club has led a nomadic existence, never having a permanent home or grounds. Over the decades, they trained in various open spaces, before developers built houses on them, such as Ardagh Park, Avondale, Obelisk Park, etc, and also local schools, and in Blackrock Park. These days the club has a portacabin in Carysfort Park, beside the UCD Smurfit campus.

Some locals may remember the Annual Christmas Morning Run, when toys and sweets were delivered to the orphan boys in St Teresas on Temple Road – in 1948, there were 142 boys eagerly awaiting the runners.

SOCCER CLUBS

In the first half of the twentieth century, there were quite a few soccer clubs in the Blackrock area, such as Williamstown United, Martello, Rockville, Merrion Rovers, Cross Celtic, Boro United, some of whom played in Blackrock Park. Bradmola Hosiery had a team, and even sponsored the Bradmola Cup.

SCOUTS

In 1956, the scouts acquired 2 acres beside the railway track at Tobernea Terrace, on Seapoint Avenue, and built the present clubhouse in 1962.

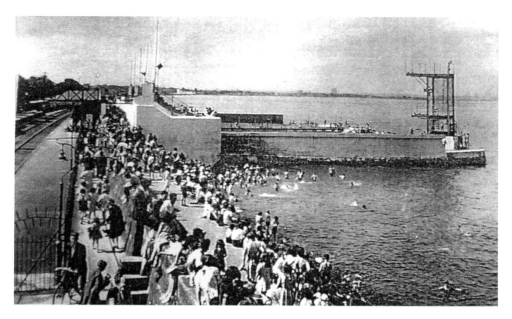

Prior to the advent of Joe Walsh Tours to Spain in the 1960s, people flocked to Blackrock to cool down and socialise. (Courtesy of the National Library of Ireland)

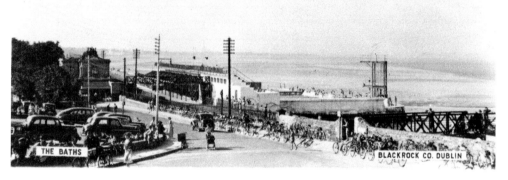

1950s postcard of Blackrock – note all the bicycles. (Courtesy of the National Library)

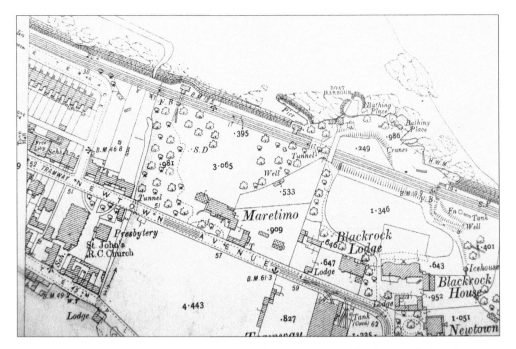

Both Maretimo House and Blackrock House, had their own pier and harbour to shelter their boats, built in 1834 by William Dargan, the railway contractor. (1907 Ordnance Survey map, courtesy of the Valuation Office)

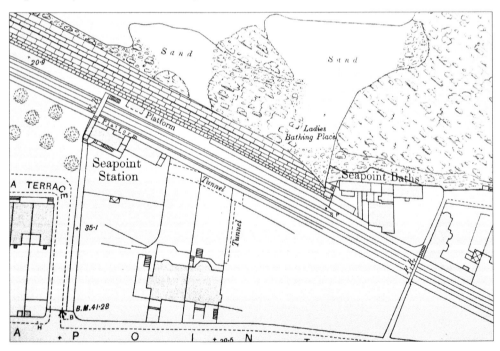

There were indoor hot and cold baths near Seapoint Station for many decades, as seen in this 1907 Ordnance Survey map. (Courtesy of the Valuation Office)

I.A.S.A. CHAMPIONSHIPS
Present Holders and Record Times

Ladies 100 Yards Free Style:
Holder, Miss G. Deane (Dublin S.C.). Record 69 3-5 secs. (Holder).

Ladies 220 Yards Free Style:
Holder, Miss G. Deane (Dublin S.C.). Record 3 mins. 0 1-5 secs. (Miss M. E. Ashenhurst).

Ladies 440 Yards Free Style:
Holder, Miss G. Deane (Dublin S.C.). Record 6 mins. 34 1-5 secs. (Miss M. E. Ashenhurst).

Ladies Springboard Diving:
Holder, Miss D. Dermody (Pembroke S.C.).

Mens High Diving:
Holder, Mr. E. Heron (Sandycove S.C.).

Mens Springboard Diving:
Holder, Mr. J. Beedim (Donegal S.C.).

Mens 100 Yards Free Style:
Holder, Mr. W. H. H. Deane (Sandycove S.C.). Record 59 2-5 secs. (W. J. A. Lowry).

Mens 220 Yards Free Style:
Holder, Mr. W. H. H. Deane (Sandycove S.C.). Record 2 mins. 30 secs. (Holder).

Mens 100 Yards Breast Stroke:
Holder, Mr. J. McCarthy (Dolphin S.C.). Record 78 3-5 secs. (L. Maher).

Mens Senior Squadron:
Holders, Sandycove S.C.

Youths (under 18 years) 100 Yards Free Style:
Holder, W. H. H. Deane (Sandycove S.C.). Record 60 secs. (W. J. A. Lowry).

Mens 100 Yards Back Stroke:
Holder, Mr. W. H. H. Deane (Sandycove S.C.). Record 74 2-5 secs. (H. McCormick).

Mens 440 Yards Free Style:
Holder, Mr. W. H. H. Deane (Sandycove S.C.). Record 5 mins. 31 2-5 secs. (Holder).

Mens Half-Mile Free Style:
Holder, Mr. W. H. H. Deane (Sandycove S.C.). Record 12 mins. 24 2-5 secs. (R. N. Case).

Mens Mile Free Style:
Holder, Mr. W. H. H. Deane (Sandycove S.C.). Record 25 mins. 18 secs. (Holder).

The Life Saving Teams Championship:
Holders, East End S.C.

The Irish Water Polo Cup:
Holders, Clontarf S.C.

Irish Amateur Swimming Association, 1941. (Courtesy of the National Library)

Leinster branch, IASA, Executive Council, 1942. From left to right, back row: C.J. Heather, P.J. Lavery, B.T. Walsh, J. Byrne, C. Warren, L. Boyd, P.J. Condon. Front row: J.E. Doyle, B.T. Barry, T.H. Corrigan (President), E. Heron. (Courtesy of the National Library of Ireland)

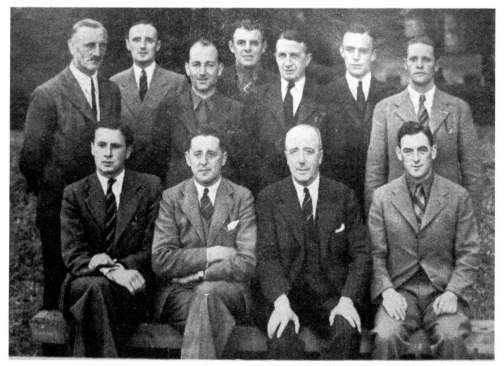

1943, Golden Jubilee, IASA. Past Presidents. From left to right, back row: W.J. McCormick (1942), A.A. Healy (1941), J. Allen (1940), J.P. Weldon (1938), W. McCreedy (1935), H.G. Ellerker (1934), H. Lemon (1922), A.J. Cullen (1928). Front row: W. Cheater (1927), M.A. O'Connor (1926), N.M. Purcell (1920), J.P. Bradley (1943), J. Beckett (1923), H.M. Dockrell (1911), P.J. Stokes (1905). (Courtesy of the National Library of Ireland)

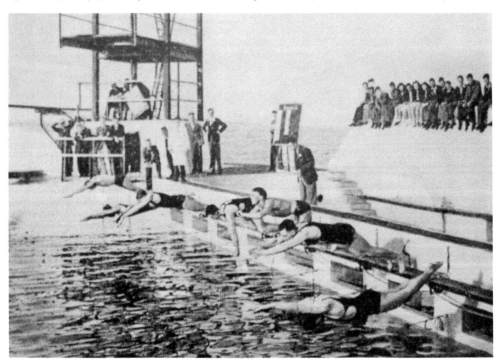

Blackrock Baths, 1943. IASA Golden Jubilee Gala. (Courtesy of the National Library)

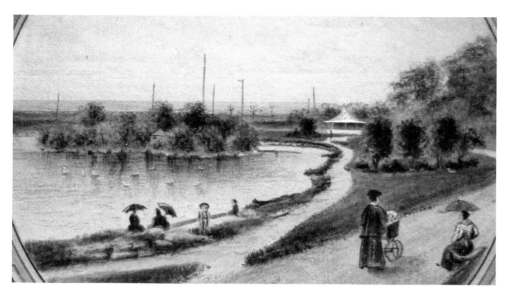

Painting of Blackrock Park, 1898. (Courtesy of the Senior College Dún Laoghaire)

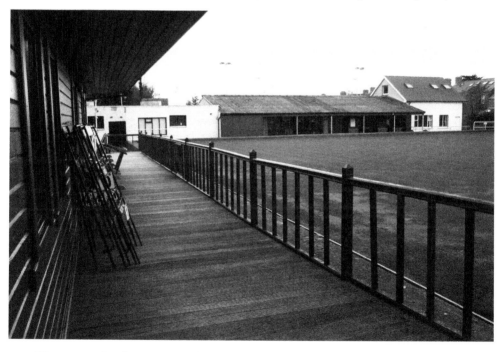

The present bowling green and new clubhouse of Blackrock Bowling & Tennis Club at Green Road. The tennis courts are beyond the clubhouse.

Blackrock Bowling & Tennis Club, Ladies and Men's first teams, 1961. From left to right, back row: Ciaran Ryan, Joe O'Malley, Shay O'Sullivan, Trevor Murphy, Brendan Lynch, Tony Hayes. Front row: Joan Morley, Deirdre O'Brien, Kathleen Perry, Jacqueline Martin, June Martin, Emer McNevin. (Courtesy of the Blackrock Bowling & Tennis Club)

6

TRANSPORT

RAILWAY/DART

The first passenger railway in Ireland ran on 9 October 1834, between Dublin and Kingstown (now called Dún Laoghaire). William Dargan was the famous contractor, who went on to build many more railways.

Dargan was halted in his tracks at Blackrock by two landowners who refused to allow the railway to cut off their access to the seashore, thus forcing Dargan to carry out extra works to compensate them. Lord Cloncurry (the Lawless family) in Maretimo House was provided with a fancy bridge across the track, and also a pier for his boat. John Lees in neighbouring Blackrock House got a better deal: Dargan cut a train tunnel under Lees' back garden and also built him a small harbour for his boat. These days, the fancy bridge and harbour are still standing, and red-brick Blackrock House has been converted to flats, but Maretimo House was demolished in 1971 in preparation for a modern block of apartments.

Dargan built Blackrock Station in 1834, and laid out nearby bathing places for the public (the public baths were not built until 1887). Idrone Terrace houses were built not long after the arrival of the railway.

In 1984, Córas Iompair Éireann electrified the Dublin section of the railway line, in a programme called DART – Dublin Area Rapid Transit. Blackrock Station was refurbished in 2005, including the installation of lifts, and the provision of an unsightly new pedestrian bridge.

TRAMS

Horse-drawn trams, running on iron tracks, started in Dublin in 1872, with the first line to Rathgar opening that year.

A separate company, Dublin Southern District Tramways Co., opened two lines in 1879, one from Kingstown to Dalkey, and the other from Haddington Road to Blackrock (Newtown Avenue). The latter line had a 2-acre depot at Shelbourne Road (now Ballsbridge Motors).

In 1885, the Blackrock and Kingstown Tramway Co. opened a line from Blackrock to Kingstown, with a depot at Newtown Avenue in Blackrock.

In 1896, all the smaller operators were taken over by the Dublin United Tramways Co., and the Haddington Road to Dalkey line was rebuilt and electrified that same year – the first electric line in Ireland. The power station was in Shelbourne Road, comprising boilers, steam engines, electricity generators, and a tall brick chimney, with substations in Blackrock (beside the tram depot) and Dalkey. Also in 1896, the line was extended from Haddington Road to Nelsons Pillar (now the site of 'The Spire' in O'Connell Street).

The DUTC built a new depot in Blackrock in 1896 (alongside the original one in Newtown Avenue), which could hold thirty-six trams. They also built workers' cottages to the north of the depot around 1910.

The symbol on the front of the Blackrock/Kingstown/Dalkey line was a green shamrock (overlain with a yellow K for Kingstown), and No. 6 went to Blackrock, No. 7 to Kingstown, and No. 8 to Dalkey.

Buses began to rival trams in the 1930s and '40s, and the Blackrock line was the last to close on 9 July 1949. Córas Iompair Éireann (CIÉ) took over transport from private buses in 1953. The former depot was in recent years used by Europa Mazda garage, but now lies empty and awaits the next 'Celtic tiger'.

BLACKROCK BYPASS

This dual carriageway opened in 1987, to relieve traffic congestion in Blackrock village. Two pedestrian subways were included: one at the lower end of Carysfort Avenue, and the other outside the entrance to Lios an Uisce (bottom of Mount Merrion Avenue), but the latter was recently closed off and partially filled in.

Modern view of Blackrock railway station. The public baths are in the background, including the diving boards.

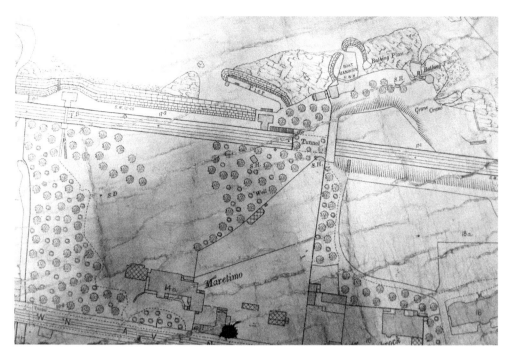

Lord Cloncurry of Maretimo House was compensated in 1834 by railway contractor William Dargan, whereby Dargan built a pier for his boat and a fancy bridge over the new railway to allow access to the beach. (Courtesy of the Valuation Office)

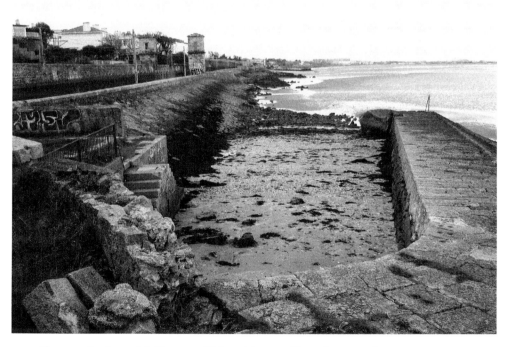

Cloncurry's pier and bridge are still in existence, although not used.

The two towers of Cloncurry's bridge are still standing.

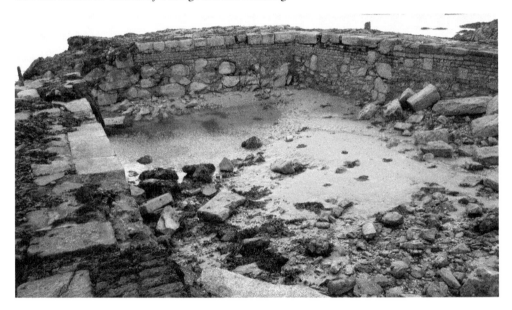

The harbour built by Dargan for Lees of Blackrock House is still intact.

The Lees harbour and summerhouses are still to be seen.

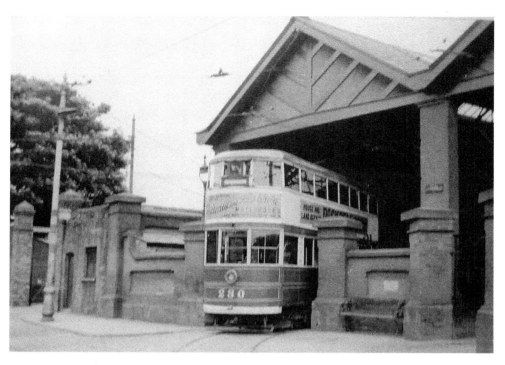

Luxury Saloon 280 emerging from Blackrock Depot in the early twentieth century. (Courtesy of the F.N.T./Lloyd Jones/Michael Corcoran)

Inside Blackrock tram depot, 1947. (Courtesy of the H. Foyle/Irish Railway Records Society)

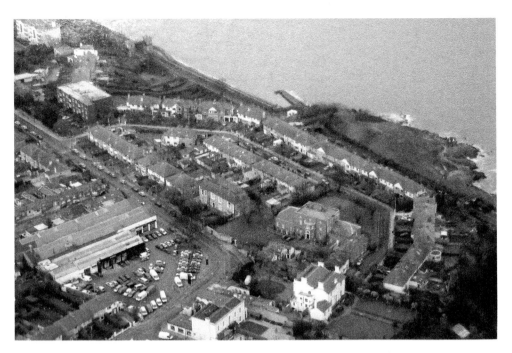

An aerial view of Blackrock Tram Depot in 2008. The big shed dates from the electrification in 1896, while the smaller shed was built in 1885 for horse-drawn trams. (Courtesy of Hooke & McDonald Commercial)

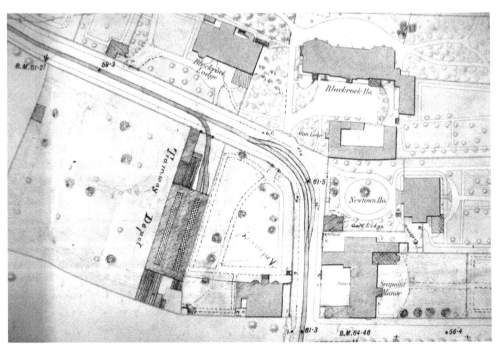

Blackrock Tram Depot, *c.* 1880. 'Dove House' was the residence at the south-west of the site. (Courtesy of the Valuation Office)

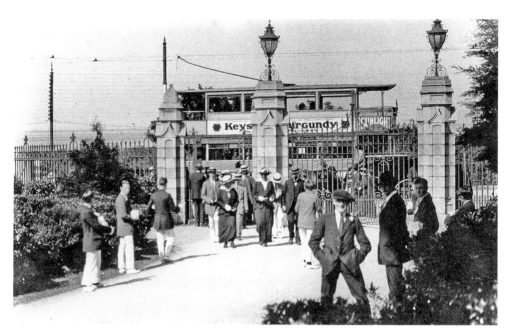

The tram outside the entrance to Blackrock College, *c.* 1904.

New electric trams in Northumberland Road in 1896. (Courtesy of the National Library of Ireland)

A new electric tram beside Monkstown Anglican church in 1896. (Courtesy of the National Library of Ireland)

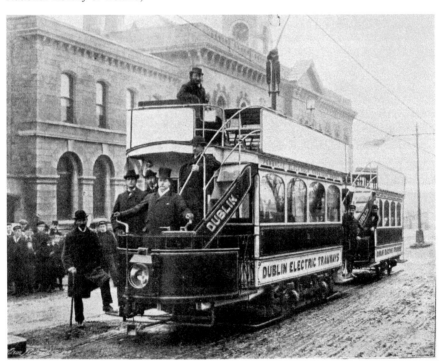

A new electric tram outside Kingstown Town Hall (now Dún Laoghaire Rathdown County Council) in 1896. (Courtesy of the National Library of Ireland)

7

BUSINESS

BANKS

The National Bank of Ireland opened in 1916 at 32 Main Street, in a premises formerly occupied by Donegan fruiterer. It is now part of Bank of Ireland next door in the former Findlater's grocery (28–30 Main Street).

The red-brick Ulster Bank, 27–35 Main Street, opposite Bank of Ireland, was built in 1892, to a design by W.M. Mitchell.

The very attractive Post Office, near Rock Hill, was built in 1909, and is now Starbucks coffee lounge.

SHOPS AND PUBS

Frescati House (built in 1739) was the childhood home of Lord Edward FitzGerald, United Irishman. He lived here from 1793 until his execution in the 1798 Rebellion. From the 1840s the large house was subdivided into four houses, all leased to respectable families. There was enormous controversy over a planned development, but the historic house was demolished in 1983 to make way for Roches Stores. Roche's was rebranded as Debenhams Ireland and is the anchor tenant in the Frescati Shopping Centre. Lisalea House at the corner of Mount Merrion Avenue was later demolished for an apartment development.

The Blackrock Shopping Centre, with SuperValu as the anchor tenant (it was Superquinn for many years) was opened in 1984, and required the demolition of Fitzwilliam Lodge, Frescati Lodge, Woodville, Laurel Hill, and some smaller houses on Rock Hill.

The famous Findlater's grocery traded in Blackrock at 28-30 Main Street, from 1879 to 1969. The Bank of Ireland demolished the shop to make way for their modern branch. Findlater's started in O'Connell Street (Sackville Street) in 1823, and had branches all over Dublin, most with a triangular Chancellor clock on the front.

Jack O'Rourke's pub has been trading from 15 Main Street since 1925, although the building dates from 1897, and was a favourite with Gardaí from the adjoining station at 15 Main Street. In 1764 the principal inn in Blackrock was the Sign of the Ship, although another popular establishment in 1784 was the Three Tun Tavern.

The Blackrock Market, a collection of tiny shops and stalls, now trades from the old premises beside the former Garda station.

BLACKROCK KINEMATOGRAPH THEATRE LTD/ REGENT CINEMA, MAIN STREET

This early cinema was at 13 Main Street from about 1915 to 1930, beside the present Jack O'Rourke's pub. The building was used as the Regent Cinema from 1938 to 1960, with capacity of about 350, and then sold. The last film was *I'm All Right Jack*, starring Peter Sellers. The building had a small frontage of 32 feet and a depth of 162 feet, with the standard corrugated asbestos cement roof. It was recently rebuilt as Cafe Java and apartments.

BLACKROCK LAUNDRY CO. LTD, BROOKFIELD AVENUE

This laundry traded from about 1901 to 1945 from a site at the corner of Brookfield Avenue and Sweetmans Avenue, where a builders' provider's is now located. Miss B. Clotworthy is listed as the manageress in 1910, and Mr W.H. Mellon as manager in the 1930s. In 1907, the company was heavily fined for seven cases of girls under 18 years working more than a sixty-hour week, and three cases of girls over 18 years working more than sixty hours in addition to overtime. The business was taken over by the Harold's Cross Laundry around 1943, but closed soon afterwards, possibly on account of the famous strike in 1945 by female workers all over Dublin. In 1945, the premises is listed as a Twine and Cord Works, with S. Henry as manager. In the 1950s, F.H. Steele & Co., manufacturing sweets, was based here.

BLACKROCK HOSIERY CO. LTD, CARYSFORT AVENUE AND BROOKFIELD TERRACE

It is reputed that this business was founded in the 1890s by Fr Watters from St John the Baptist church, and that it was taken over in 1903 by Alderman George Tickell (Dublin Corporation). A few years later, Mr Crawford is listed as a director.

When Brookfield Terrace houses were built around 1907, the hosiery factory was rebuilt and enlarged to fit-in with the streetscape.

In the 1930s, W.E. Crawford was the managing director, with a registered address at 5 Crown Alley, Dublin 2, and they had an additional building at 74b Carysfort Avenue (Whitehall House/former Avoca School – now Blackrock Business Park, and An Post sorting office site). The company made 'Rock' and 'Eblana' underwear and outerwear, and had showrooms at 44 Dawson Street. The company did their own dyeing.

The business closed in 1957 and the following year, the Carysfort buildings were used as Flittermans Carpet Manufactory. Then Glen Abbey Hosiery Company took over the laundry and hosiery site in the 1960s. In recent years the site has been redeveloped as the Blackrock Business Park, but An Post sorting office still occupies an old factory building. The former factory on Brookfield Terrace/Place is now used by different small enterprises.

BRADMOLA MILLS LTD, CARYSFORT AVENUE

This famous company was founded in 1934 by A.H. Bradbury, G.A. Bradbury, J.J. Morris, Bertha Morris and Stuart Lane. The first few letters of their surnames created the company name: Brad-Mo-La. They specialised in making women's nylon stockings, using the Mannequin trade name. Their initial premises was on the west side of the Meath Industrial School site, in the former gym (beside Walnut Lodge). In the 1950s and '60s they were in 74b Carysfort Avenue, beside Blackrock Hosiery (now Blackrock Business Park, including An Post sorting office), working around the clock in three shifts, and employing 360 people, mainly women. They also owned Prescott's Dye Works, employing a similar number of workers. Stuart Lane was also involved in the Irish Tapestry Co. in Drogheda.

There was a Bradmola-sponsored radio programme on Radió Éireann in the 1950s, on Thursdays at 2.15 p.m. The company also sponsored the Bradmola Soccer Cup.

The Irish Times held a competition in February 1953, featuring eight pretty girls from Bradmola. Readers had to pick their favourite six out of the eight, from different companies every week – Clerys of O'Connell St featured the week after Bradmola.

Glen Abbey Hosiery Co. (based in Tallaght) took over Bradmola in 1964, although Stuart Lane retained ownership of Prescott's Dye Works.

APEX MANUFACTURING CO. (1935) LTD, SOUTH END OF BROOKFIELD TERRACE

This clothing manufacturer built a new factory to the east of the former Meath Industrial School in 1935 and traded here until 1982, with the loss of seventy jobs (in the 1960s about 150 were employed). They made shirts, sheets, pillows, calicoes, cotton drills, 'Sanforized' shrunk overalls. They were based in 14, 15 and 16 Little Ship Street (beside Dublin Castle) from 1928, but following liquidation and the creation of the new company in 1935, they moved to Blackrock, with the aid of a State-guaranteed loan of £6,000. The directors in 1935 were Samuel Boden, William Charles Bell, and Jonathan Cole. In 1941 the directors were Jonathan Cole, V.E. Cole, and G.G. Williamson. Cole, who was from Ballyfin, County Laois, lived in Sydney Avenue, where he died, aged 77, in 1959, and was buried in St Brigid's graveyard, Stillorgan.

Dublin Crystal Glass Co. was based here from 1984 to 2001, before moving to their present premises in Dundrum (they were in the gym of the former Meath Industrial School from 1970 to 1984).

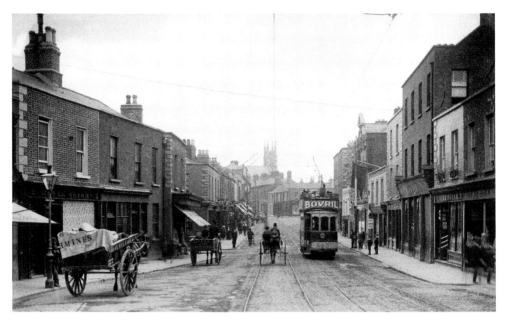

Main Street, Blackrock, looking south, *c.* 1900. (Courtesy of the National Library)

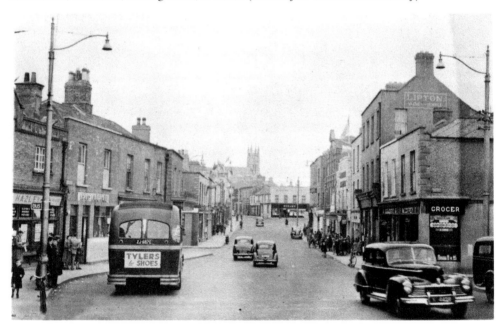

Main Street, Blackrock, looking south, *c.* 1950. (Courtesy of the National Library)

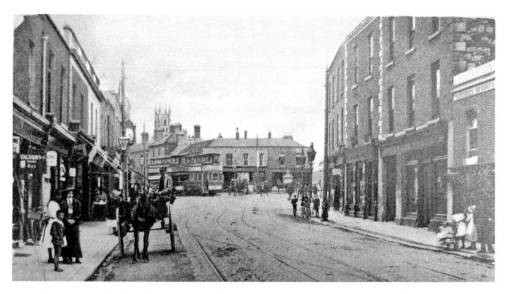

Main Street, Blackrock, looking south, *c.* 1910. (Courtesy of the National Library)

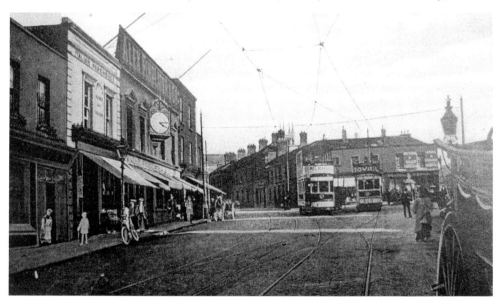

Main Street, Blackrock, looking south, *c.* 1920. (Courtesy of the National Library)

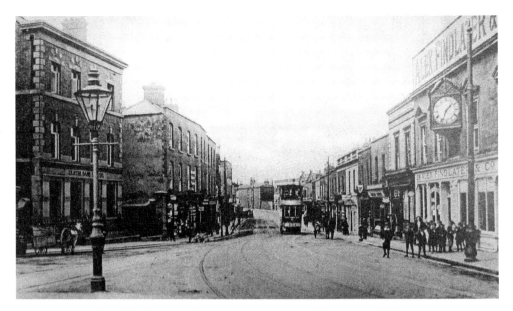

Main Street, Blackrock, looking north, *c.* 1900. (Courtesy of the National Library)

Junction of Carysfort Avenue and Main Street, Blackrock, looking west, *c.* 1900. (Courtesy of the National Library)

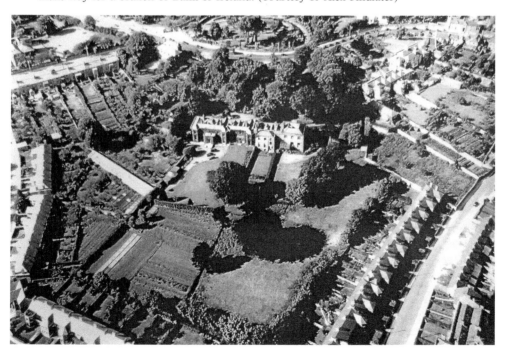

Findlater's grocery was in Blackrock from 1879 to 1969. This building was demolished to make way for a branch of Bank of Ireland. (Courtesy of Alex Findlater)

A 1950s aerial rear view of Frescati House, which was demolished in 1983 to make way for Roches Stores (now Frascati Shopping Centre). (Courtesy of the National Library)

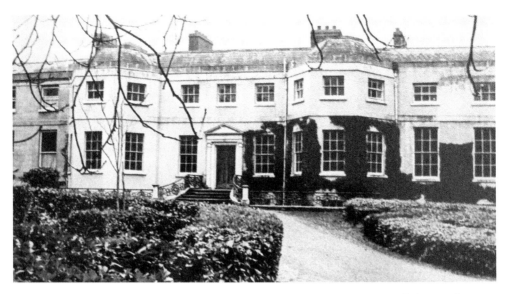

Frescati House was originally the childhood home of Lord Edward FitzGerald, but in the nineteenth and twentieth centuries it was subdivided into four separate dwellings. The family also owned Leinster House in Kildare Street, which later became the headquarters of the (Royal) Dublin Society, and is now Dail Éireann. (Courtesy of the National Library)

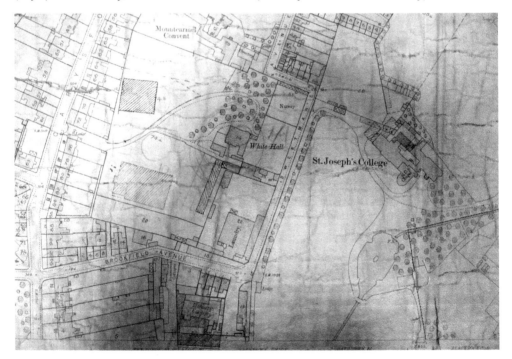

Map of 72b Carysfort Avenue (now Blackrock Business Park). 'Whitehall' became Avoca School. Blackrock Laundry, meanwhile, is visible at the corner of Brookfield Avenue and Sweetmans Avenue. Blackrock Hosiery Co. and Bradmola Hosiery Co. had factories in the estate in the 1930s to 1950s. (Courtesy of the Valuation Office)

1942 Union members of Blackrock Laundry. (Courtesy of the Irish Labour History Museum)

Blackrock Hosiery Co. in the 1930s. (Courtesy of the Dublin City Library & Archives)

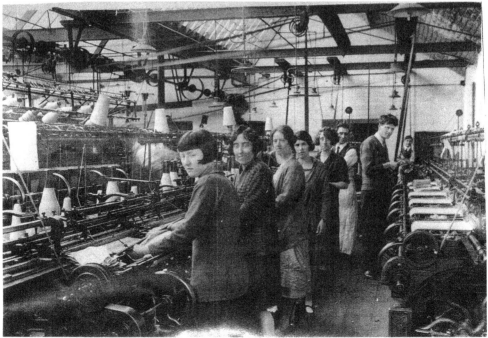

Blackrock Hosiery Co. in the 1930s. (Courtesy of the Dublin City Library & Archives)

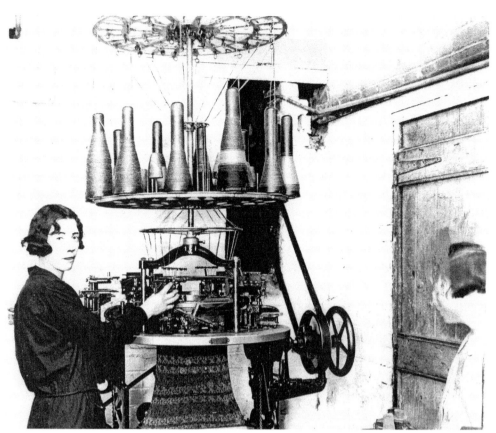

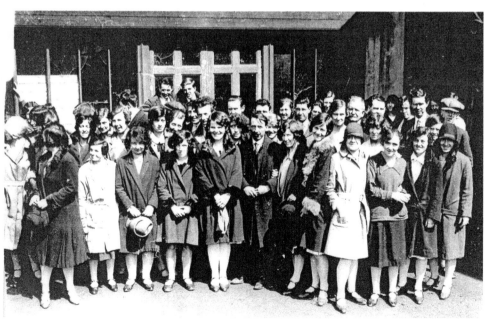

Blackrock Hosiery Co. in the 1930s. (Courtesy of the Dublin City Library & Archives)

The Blackrock Hosiery Co., Ltd.

The Blackrock Hosiery Co., Limited

BLACKROCK, CO. DUBLIN.

PRICE LIST. *SPRING, 1924*

THE 'Rock' UNDERWEAR

TERMS—2½% Monthly Account.

SPORTING JERSEYS.

H. **Quality Plain Stand Collar.** Fashioned in Brown, Green, Grey Heathers, Navy, Red, Royal, Saxe, White, Yellow and Black, per dozen :—

32″	34″	36″	38″
64/-	66/-	68/-	73/-

For multiples of ½ doz. to a size : Odd Jerseys 10% extra.

Extras, per dozen:—

Laced Front	**5/-**
Polo Collar, Laced or Buttoned Front	**9/-**		
Linen Collar, Buttoned Front		**15/-**	
Each Additional Colour	**3/-**	
Sash	**12/-**
Fashioned Waist	**3/-**

FOOTBALL HOSE.

Plain legs, with T.D. tops. Self colour	...	**32/-**
Self colour legs, with T.D. different colour tops	...	**36/-**
Striped legs, with striped T.D. tops	...	**40/-**

GOLF HOSE.

285	Lovats. Fancy tops	**60/-**
263	Handknitted Lovats. Fancy tops	**72/-**

Men's Cardigans

331 Fcy. Mixts.
333 Cashmere

White Sweaters

V Neck
332 All Wool

The 'Rock' Guarantee of Quality.

MEN'S UNDERWEAR.

			M. Shirts Price	M. Trousers Price	Slr. size less.	O.S. extra
CASHMERE FINISH NATURAL						
A1	Summer Weight	...	40/-	46/-	0	6/-
A3	Medium	...	48/-	54/-	0	6/-
A2X	Medium. All Wool Face	54/-	60/-	0	6/-	
195X	Heavy Do.	...	64/-	70/-	0	6/-
LAMB'S WOOL						
C	Shetland Heavy	...	50/-	56/-	0	6/-
D	Natural Heavy	...	50/-	56/-	0	6/-
A13F	Natural Heavy	...	60/-	66/-	0	6/-
A11F	Shetland Heavy	...	60/-	66/-	0	6/-
283	Natural Heavy	...	88/-	96/-	2/-	8/-
267	Natural Medium	...	100/-	106/-	2/-	8/-
PURE NATURAL WOOL						
E	Medium	...	64/-	70/-	0	6/-
250F	Medium	...	72/-	78/-	1/-	6/-
299	Heavy	...	84/-	90/-	1/-	8/-
286	Light Medium	...	96/-	102/-	1/-	8/-
257	Heavy	...	100/-	106/-	2/-	10/-
PURE NATURAL BOTANY						
300	Summer Weight	...	88/-	96/-	2/-	8/-
289	Light	...	96/-	104/-	2/-	10/-
275	Medium	...	114/-	122/-	2/-	10/-
274	Heavy	...	126/-	134/-	2/-	10/-
304	De Luxe Medium	...	132/-	140/-	4/-	10/-

Pope's Size stocked in 275, 274, and 304.

MEN'S HALF HOSE.

Fine Ribbed.				Heavy.		
292	Heathers	...	18/6	278H Heathers	...	16/-
264H	Heathers	...	24/6	278G Grey	...	16/-
264G	Grey	...	24/6	AG Army Grey	...	14/-
F	Fancies	...	26/6	295H Heathers	...	16/6
L	Lovats	...	24/6	295G Grey	...	16/6
B	Black	...	26/6	296 Heathers	...	24/-
N	Navy	...	26/6	265H Heathers	...	30/-
W	White	...	20/-	265G Grey	...	30/-
Fine Cashmere—Plain.				BB Black	...	32/-
322	Fancy Mixtures	21/-		NN Navy	...	32/-
320	Mottles	...	26/6			

Part of a 1924 price list for Blackrock Hosiery Co. (Courtesy of the Dublin City Library & Archives)

One section of the former factory of Blackrock Hosiery Co. is still in Brookfield Terrace, backing on to Brookfield Place, and now in a variety of uses.

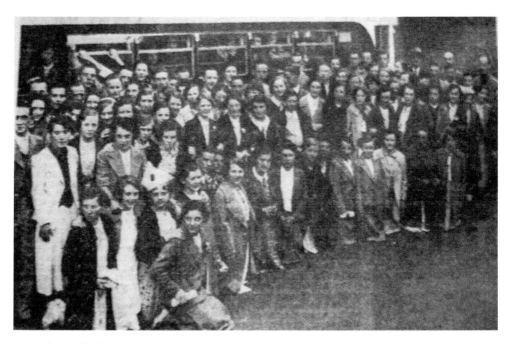

The staff of Bradmola Hosiery Co. about to leave on a bus from Carysfort Avenue on their Annual Excursion, 1937. (Courtesy of the *Irish Press*)

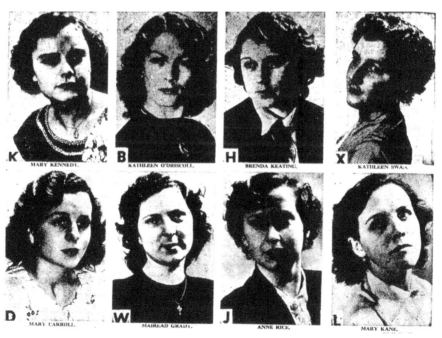

Eight girls from Bradmola Hosiery Co. featured in an *Irish Times'* competition in February 1953. From left to right, top row: Mary Kennedy, Kathleen O'Driscoll, Brenda Keating, Kathleen Swan. Bottom row: Mary Carroll, Mairead Grady, Anne Rice, Mary Kane. (*Irish Times* extract courtesy of the Dublin City Library & Archives).

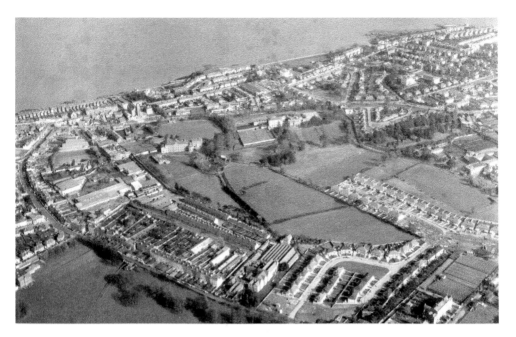

Aerial photo of Blackrock, with Carysfort Avenue along the bottom, 1973. (Courtesy of the National Library)

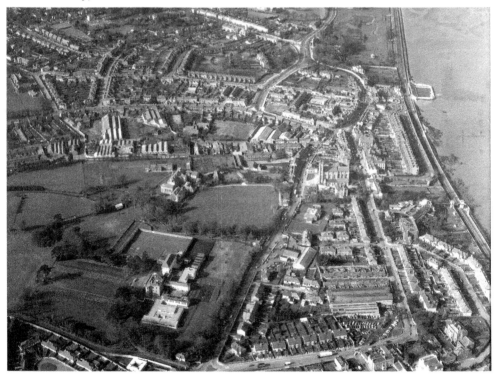

Aerial photo of Blackrock, looking north, 1973. St Theresa's Boys' Orphanage is the big complex at lower left. (Courtesy of the National Library)

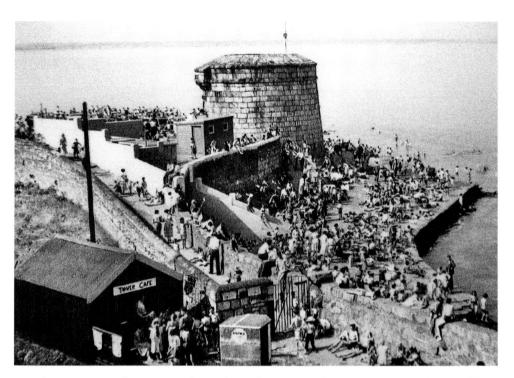

Seapoint Martello Tower and seaside in the 1950s, when summers were long and hot, and Spain hadn't been discovered. (Courtesy of Dún Laoghaire Rathdown County Council)

Also from The History Press

Irish
Revolutionaries

TOM
CLARKE
THE TRUE LEADER OF
THE EASTER RISING
MICHAEL T. FOY

THAT
IRISHMAN

THE LIFE AND TIMES OF
JOHN O'CONNOR POWER
JANE STANFORD

BOY
REPUBLIC
PATRICK PEARSE
AND RADICAL
EDUCATION
BRENDAN WALSH
FOREWORD BY DECLAN KIBERD

'A monumental task handled with style and
aplomb in a compelling and entertaining narrative'
– MYLES DUNGAN

Parnell
A NOVEL
BRIAN CREGAN

DEFYING
THE LAW OF
THE LAND
AGRARIAN
RADICALS IN
IRISH HISTORY
EDITED BY BRIAN CASEY
FOREWORD BY CARLA KING

Find these titles and more at
www.thehistorypress.ie

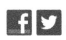 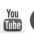